PERSPECTIVE DRAWING Handbook

PERSPECTIVE DRAWING Handbook

By JOSEPH D'AMELIO

 Van Nostrand Reinhold Company
New York Cincinnati Toronto London Melbourne

First published by Van Nostrand Reinhold in 1984

Copyright © 1964 by Leon Amiel, Publisher

Library of Congress Catalog Card Number 83-12399

ISBN 0-442-21828-1

Printed in the United States of America

Van Nostrand Reinhold Company Inc.
135 West 50th Street
New York, New York 10020

Van Nostrand Reinhold Company Limited
Molly Millars Lane
Wokingham, Berkshire RG11 2PY, England

Van Nostrand Reinhold
480 Latrobe Street
Melbourne, Victoria 3000, Australia

Macmillan of Canada
Division of Gage Publishing Limited
164 Commander Boulevard
Agincourt, Ontario M1S 3C7 Canada

16 15 14 13 12 11 10 9 8 7 6 5 4 3 2 1

Library of Congress Cataloging in Publication Data
D'Amelio, Joseph
 Perspective drawing handbook.

 Reprint. Originally published: New York: Leon Amiel, © 1964.

 1. Perspective. 2. Drawing—Technique. I. Title.
 NC750.D3 1984 742 83-12399
 ISBN 0-442-21828-1

CONTENTS

INTRODUCTION

AN UNDERSTANDING OF PERSPECTIVE is mandatory for all students and professionals involved with representational drawing. This includes a wide variety of fields, such as: Illustration, Interior Design, Architecture, Industrial Design, Engineering Design, Scenic Design and even Fine Arts. While each of these areas applies perspective techniques for different purposes and to varying degrees of thoroughness, artists in all of them must be knowledgeable and experienced in basic perspective fundamentals and principles. This book provides those essentials.

For those concerned with mechanical (T-square and triangle) perspective it explains and gives life to all the theories upon which mechanical perspective is based.

For those concerned with freehand perspective it provides all the important principles, insights and "shortcuts" necessary for effective drawing and life sketching.

Furthermore, this volume has been planned as a practical reference book for the experienced artist or delineator who finds that passing time has rendered certain techniques or principles vague; and the draftsman who, immersed in a maze of mechanical perspective guidelines, feels the need to review certain fundamentals.

Dogmatic rules for memorization are avoided, for they tend to be forgotten or, even worse, stultify the imagination. Instead, principles are developed in step-by-step fashion, accompanied by explanations of their origin, value and application and often by their more or less rigorous proofs. Such a presentation hopefully will breathe vitality into these concepts and thereby result in a clearer, more intimate understanding.

It must be emphasized, though, that for the beginner these principles will have little value unless they are tested and experienced. This means continually observing perspective phenomena in real life and — more important — constantly sketching variations of each. As in swimming, golfing or piano playing, proficiency is achieved only by total involvement.

Practice should result in a sound knowledge of (1.) the actual form and structure of scenes and objects, and (2.) how these objects and scenes change appearance from different viewpoints and under different lighting conditions. Essentially, perspective drawing deals with this appearance of things, i. e., with how three-dimensional reality "looks" and how it is best drawn on two-dimensional surfaces such as a canvas, sketch pad, or illustration board.

Once these fundamentals are understood and thoroughly mastered, they might be used either in extremely "realistic" drawings or in more abstract or suggestive ones. In either case, a work will be more vital and effective, for it will be based on visual truths.

It might be worth noting, however, that all pictures are a form of abstraction or symbolism. Perspective drawing neither claims nor is able to simulate what the human eye sees. Our eyes constantly move about, change focus, see depth and color, change according to light intensity and see things with time and therefore motion. Drawings are static, flat and of a limited size.

Perspective drawing is nevertheless concerned with achieving a sense of space, of depth and of the third dimension, within the limits of the flat drawing surface. There are several visual principles which serve this end, such as DIMINUTION, FORESHORTENING, CONVERGENCE, SHADE AND SHADOW, etc. The following chapter and much of what follows explain and explore these basic concepts.

<div align="right">J. D'A.</div>

Chapter 1: FUNDAMENTALS

Diminution — Objects Appear Smaller As Their Distance From The Observer Increases

For instance, someone across the street appears smaller than the person next to you, someone down the street appears still smaller, and so on.

A good way to see this is to extend your arm forward with your hand held upright. Notice how someone close by (say 20 ft. away) stands about equal to your hand height, while someone 50 ft. away approximately equals the length of your thumb, someone 200 ft. away equals your thumbnail, and finally, someone 1000 ft. away (several blocks) equals possibly a hang-nail on that thumb.

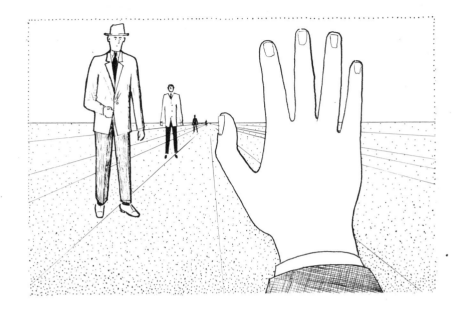

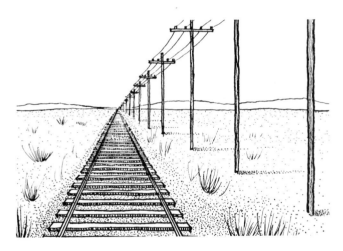

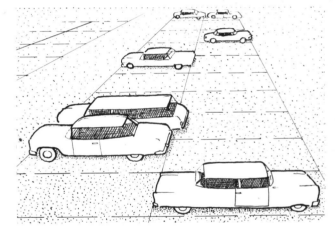

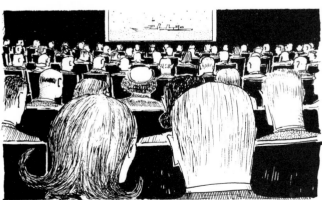

The cross-ties of railroad tracks, autos in a parking lot, heads in a theatre, and the cars of a railroad train are just a few other examples of things that we know are approximately equal in size yet which appear to diminish with distance. This "truth" of seeing, when applied to a drawing, is a fundamental means of producing a sense of space and depth.

Foreshortening — Lines Or Surfaces Parallel To The Observer's Face Show Their Maximum Size. As They Are Revolved Away From The Observer They Appear Increasingly Shorter

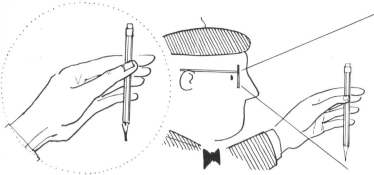

1. For instance, a pencil held parallel to observer's face will show its true and maximum length.

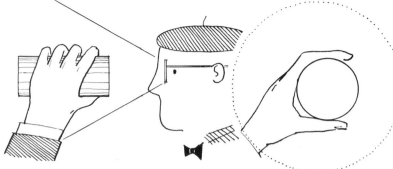

5. This tube or oatmeal box seen end-on will appear as a full circle. None of the sides are visible.

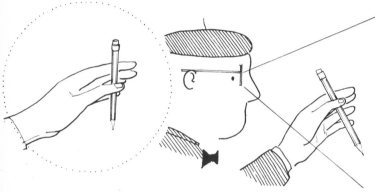

2. As it is slowly pivoted its length appears smaller . . .

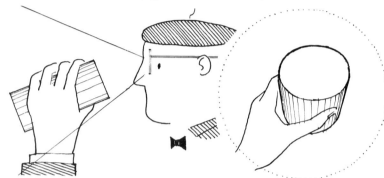

6. When it is pivoted slightly the circle "foreshortens" and appears as an ellipse. The sides (which were totally foreshortened) now begin to appear.

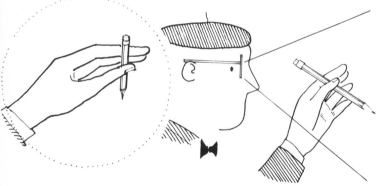

3. . . . and still smaller . . .

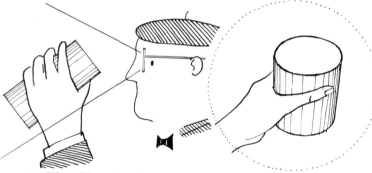

7. The ellipse foreshortens even more (it becomes flatter) while the sides appear longer.

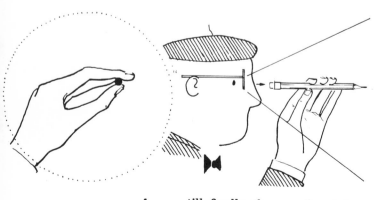

4. . . . till finally the pencil points directly at observer, and only the end is seen. This could be called 100% foreshortening.

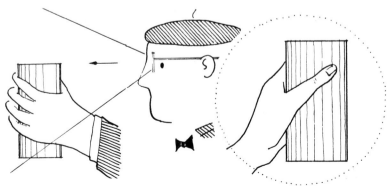

8. Finally, the circular top foreshortens to a simple straight line and the sides appear at maximum length.

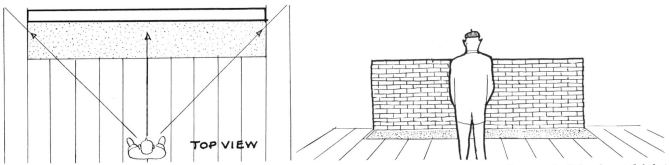

When a brick wall is seen head-on (*i.e.* — parallel to observer's face) the top and bottom lines and all horizontal joints appear truly parallel and horizontal (level with the ground).

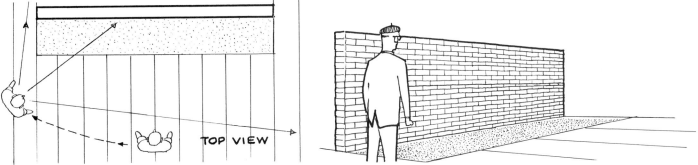

But if the observer shifts position and looks "down" the wall, then these lines cease to appear parallel and level with the ground and instead appear to come together (converge) as they recede.

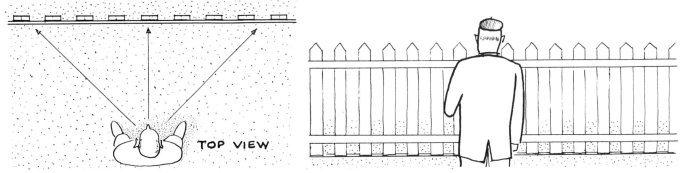

CONVERGENCE EQUALS DIMINUTION PLUS FORESHORTENING: The pickets of a fence, when viewed head-on, appear equal in height and spacing. Also, the top and bottom lines are parallel and level.

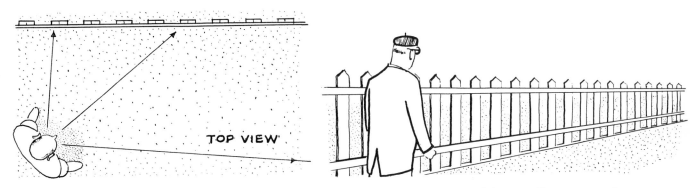

But if the observer turns his head and looks "down" the fence, then the top and bottom lines appear to converge. Notice that this convergence relates directly to the diminution of the pickets as they recede. Furthermore, the true length of the fence no longer appears, but instead is foreshortened. (Note how the spacing and width of the pickets appear narrower in the distance.)

Therefore, convergence can be thought of as the *diminution of closely-spaced elements of equal size.* And it implies foreshortening since the surface is not viewed head-on.

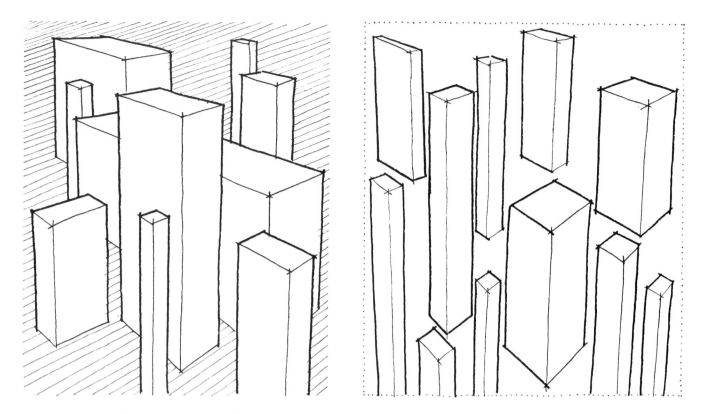

OVERLAPPING: This obvious and very simple technique not only shows which objects are in front and which are in back — it's also a very important way of achieving a sense of depth and space in drawings. Notice the depth confusion when overlapping does not exist (*right*).

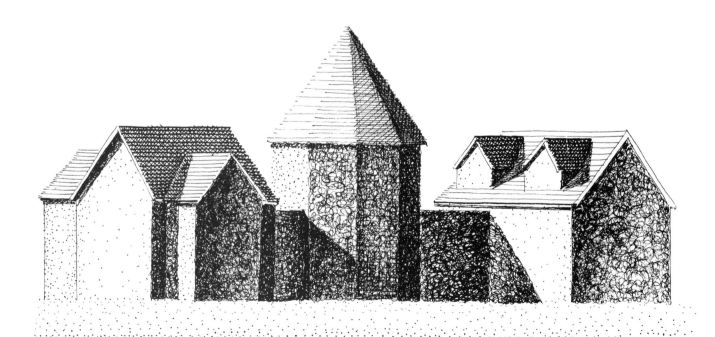

SHADES AND SHADOWS: Naturally the shape and structure of three-dimensional objects can be understood only when viewed in some form of light. But it's really the shades and shadows created by this light that render the shapes "readable" and discernable. So working with light, shade and shadow will dramatically help to give a drawing form and a sense of the third dimension.

Color And Value Perspective

Values (black to white range) and colors are bright and clear when seen close up but become grayer, weaker, and generally more neutral as their distance from the observer increases.

Detail And Pattern Perspective

Details, textures and patterns, such as blades of grass, the bark of trees, leaves, the distinguishing features of people, etc., are also clear and discernable when close but become "fuzzier" and less sharp when further away.

These principles are rarely discussed in perspective books yet they suggest useful techniques for increasing the sense of depth and space in a drawing.

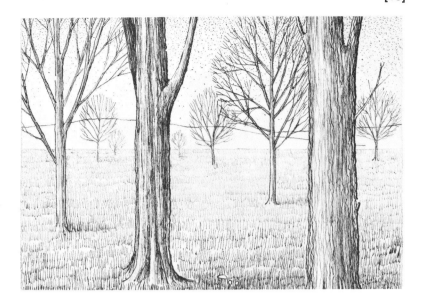

Focus Effect

This principle is worth noting despite the fact that only a few artists apply it in their work.

The eye looking at a distant object will focus at that object's range; things in the foreground, consequently, will be "out of focus" and therefore blurred.

For example, a distant steeple seen through a window might appear something like this. Such a blurred foreground-clear background effect might be used to emphasize the center of interest as well as the sense of depth.

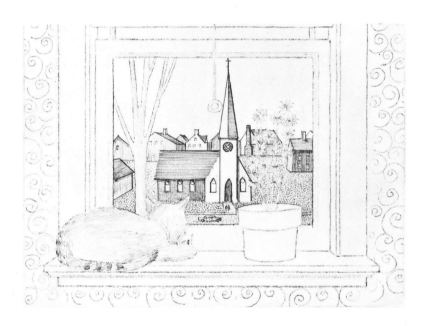

Conversely, when the eye focuses on foreground objects the background will appear blurred and unclear.

(This principle is rarely used because artists drawing a view such as this will focus back and forth in order to see and draw all parts clearly. Yet if emphasis or a "spot light" effect were desired this "truth" of seeing could well be applied.)

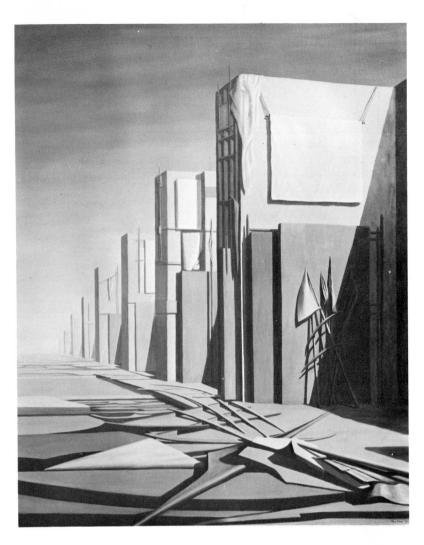

Two professional examples, a painting and a landscape drawing, employing the fundamentals of DIMINUTION, FORESHORTENING, CONVERGENCE, OVERLAPPING, SHADE AND SHADOW, VALUE PERSPECTIVE, PATTERN PERSPECTIVE, etc., to achieve a sense of space and depth.

No Passing, by Kay Sage. Collection of Whitney Museum of American Art, New York

Project for Franklin D. Roosevelt Memorial Park. Joseph D'Amelio, Architect. Don Leon, Associate. Rendering by Joseph D'Amelio

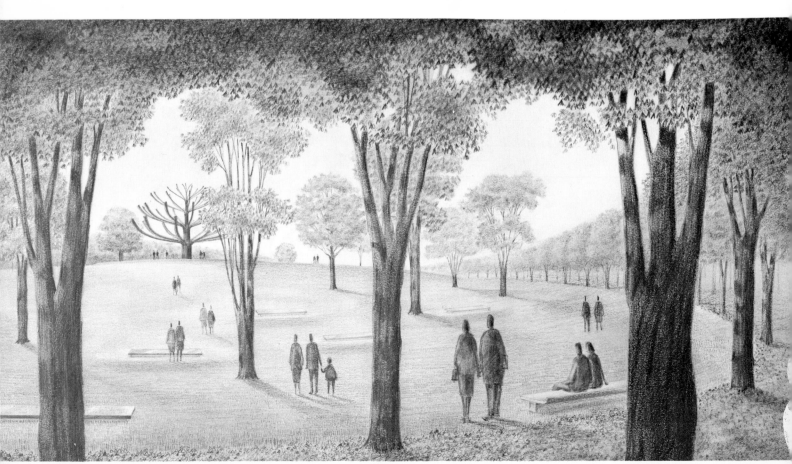

Chapter 2: REALITY AND APPEARANCE

In Perspective Drawing You Draw What You See From A Specific Viewpoint, Not Your Idea Or Mental Image Of The Subject

We think of a table, generally, as being rectangular with parallel sides, and of dishes as round.

Children, beginners, and some sophisticated artists will draw them this way regardless of viewpoint *(left)* — children because they lack visual perception, artists because they wish to express the true essence and primary nature of the subject. Both, though, are doing the same thing — they are drawing their idea or mental image of the subject.

The true appearance of dishes on a table would be elliptical shapes on a converging, foreshortened surface *(right)*.

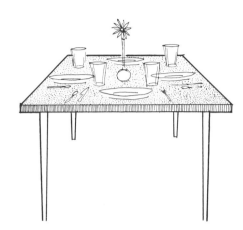

The beginner, drawing a front view of the face, would tend to draw the idea of a nose *(left)* instead of its foreshortened appearance.

The same tendency created this unrealistic eye in side view *(right)*. Again the idea was drawn instead of the true appearance.

Wave your fist at someone across the room, 15 or 20 ft. away. A beginner, thinking only of the true sizes of hands and people, would probably tend to draw the scene this way *(left)*.

But the careful observer would notice that the hand was almost one-third the height of the figure, and so draw it. Overlapping and value perspective help to dramatize the respective nearness and farness of these elements.

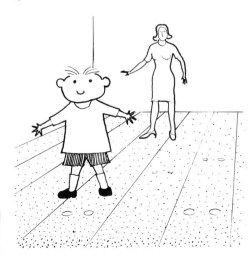

To a seated observer, a child close by and an adult further away might appear this way, and should be drawn this way. Your intellectual idea of the relative heights of children and adults might suggest differently.

A rifle pointed directly at your eyes might not appear very frightening at first, for you hardly see the lethal, yard-long weapon.

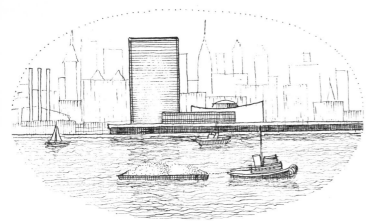

1. We all know that the U.N. tower is a simple rectangular prism whose facades are all pure rectangles. When it is viewed directly from a distance, say from across the river, this pure geometry is revealed.

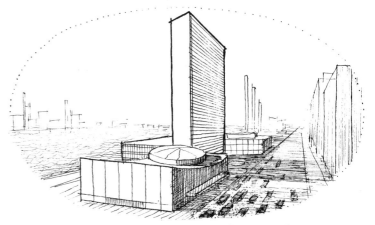

2. But when it is seen from up the river or the avenue, its facades appear foreshortened and the roof and window lines seem to converge. Only the vertical lines maintain their true directions.

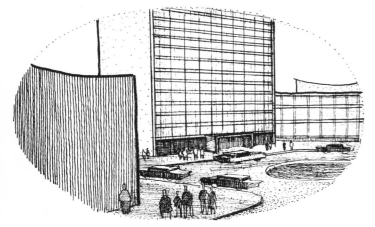

3. If we now come closer, and look straight ahead, we see the bottom of the building, the entrance, and the foreground. From this viewpoint the horizontal window lines still converge.

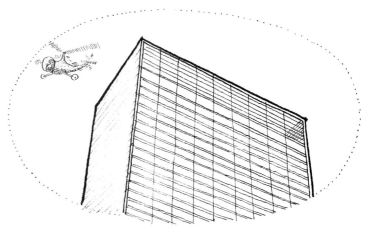

4. Upon looking up we notice that for the first time the vertical lines appear to converge (upwards). Also, the roof and window lines now converge downwards to the left and right.

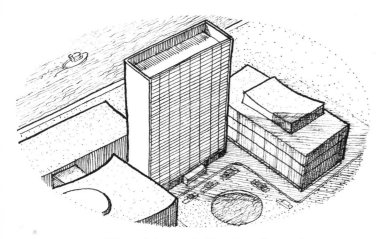

5. Viewed from a helicopter, the roof and facade rectangles again converge and foreshorten. But here vertical lines converge downwards, while horizontal lines point upwards.

6. From directly above, only the rectangle of the tower's roof is seen. This barely expresses the building's form. Adjacent buildings with converging facades are more comprehendible.

1. In reality, this bench is composed of simple rectangular prisms. A boy climbing a tree would have this rare view of its true geometry.

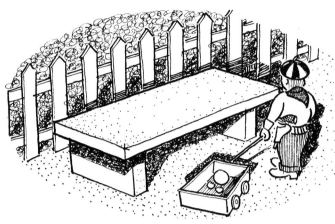

2. His parents at ground level might have this view. The horizontal and vertical lines appear to converge and all surfaces are foreshortened. (The vertical lines give a sense of verticality but they are not actually parallel to the edge of the page.) Note that this viewpoint is more revealing than the first.

3. Junior, who is only 3 ft. tall, would see it still differently. The verticals now appear truly vertical, while the horizontal lines still converge.

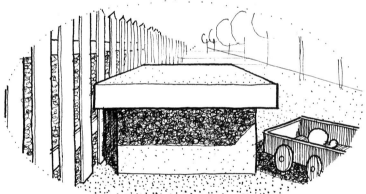

4. If Junior walked around the bench and looked at the end head-on, the true geometry of the end rectangle would appear. The bench top, though, would strongly converge and foreshorten. Notice that the horizontal as well as the vertical lines of the end maintain their real directions.

5. This "worm's eye" view, which one might get by falling on the ground and looking up, offers a unique picture of the bench. The subject is rarely drawn from this (or the first) viewpoint since it is rarely seen this way.

Chapter 3: HOW WE SEE FOR PERSPECTIVE DRAWING

Cone Of Vision . . . Central Visual Ray . . . Picture Plane

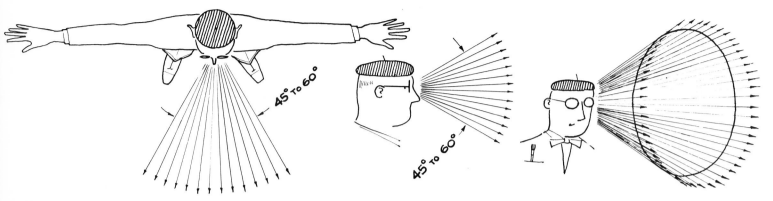

A perspective drawing will look correct only if the artist's viewpoint and his direction of viewing the subject are relatively fixed. This means drawing with a limited "field of vision." This field is usually called the CONE OF VISION because of the infinite number of sight lines which radiate in a cone-like pattern from the eye. (In reality these lines are light rays coming *from* the subject *to* the eye.) The angle of this cone is between 45 and 60 degrees. If a greater angle is used in a drawing, it implies a moving cone of vision — and the picture will be distorted. You can test your cone of vision by looking straight ahead and swinging your outstretched arms in and out of sight.

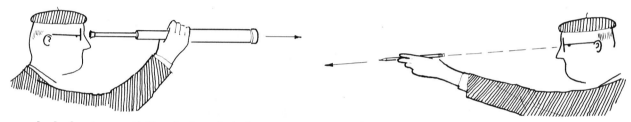

When we look about, essentially what we do is focus upon a succession of spots or "centers of interest," each of which is fixed by a sight line at the exact center of the cone of vision. This line is sometimes called the "center line of sight" or the "central direction of seeing." We shall call it the CENTRAL VISUAL RAY. When you look through a telescope or hold a pencil so that it appears as a point the telescope or the pencil is exactly on your central visual ray.

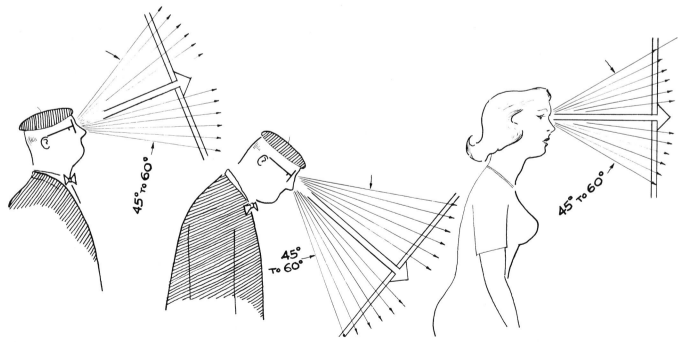

To understand perspective drawing a PICTURE PLANE must be imagined between the observer and subject. THIS PLANE HAS A CONSTANT RIGHT ANGLE RELATIONSHIP WITH THE CENTRAL VISUAL RAY. So when drawing a subject, whether it is above, below or straight ahead, imagine viewing it through an omnipresent picture plane which is perpendicular to your central visual ray surrounded by a cone of vision.

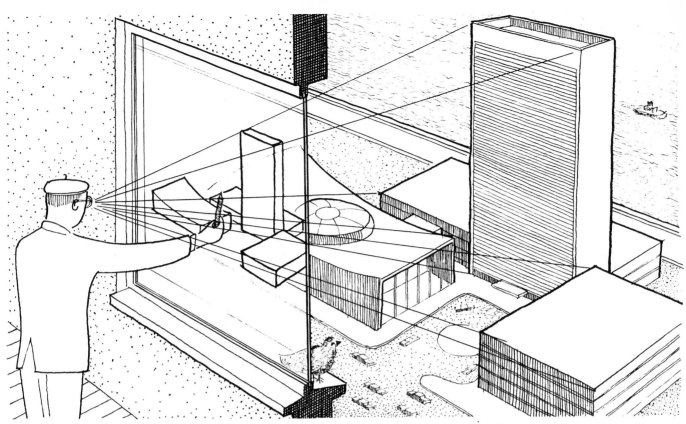

The concept of the picture plane may be better understood by looking through a window or other transparent plane from a fixed viewpoint. Your lines of sight, the multitude of straight lines leading from your eye to the subject, will all intersect this plane. Therefore, if you were to reach out with a grease pencil and draw the image of the subject on this plane you would be "tracing out" the infinite number of points of intersection of sight rays and plane. The result would be that you would have "transferred" a real three-dimensional object to a two-dimensional plane.

You can refine this experiment by looking through a window that has vertical and horizontal pane divisions, or through any transparent sheet that has been marked off in a similar grid pattern with crayon or by scoring.

Here the vertical and horizontal lines of each small rectangle clarify the direction of oblique or converging lines beyond. Working with such a "reference grid" one can easily transfer the scene to a sketch pad. This is surely not a recommended drawing technique but it does dramatically show the basic theory of perspective. In fact, the word perspective comes from the Latin word "perspecta" which means "to look through."

YOUR CANVAS, SKETCH PAD, OR DRAWING BOARD, THEREFORE, IS THE PICTURE PLANE. ON IT IS DRAWN WHAT WOULD BE SEEN IF IT WERE TRANSPARENT AND HELD PERPENDICULAR TO YOUR CENTRAL VISUAL RAY.

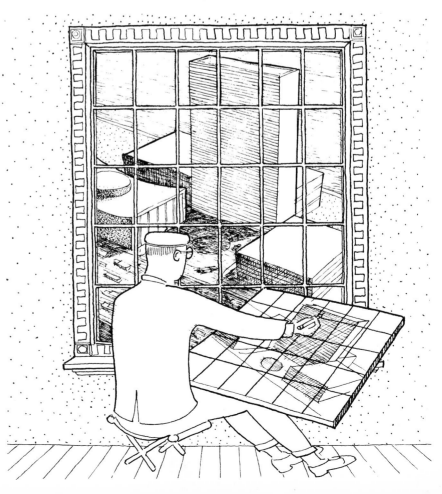

Chapter 4: WHY APPEARANCE DIFFERS FROM REALITY — THEORY

By applying the notion of "lines of sight through a picture plane" to simple views of pencils of equal length, we can more precisely define the visual basis of DIMINUTION, CONVERGENCE, FORESHORTENING, AND OVERLAPPING, and explain diagrammatically why the appearance of an object so frequently differs from its reality.

"Lines Of Sight Through Picture Plane" Applied To Diminution

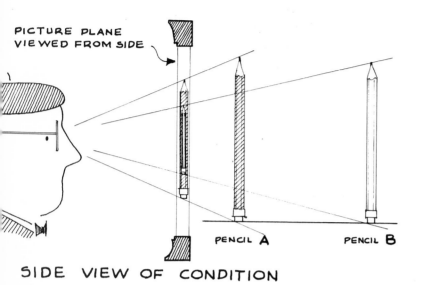

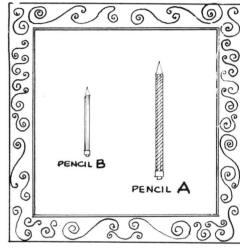

PICTURE PLANE VIEWED FROM SIDE

PENCIL A PENCIL B

SIDE VIEW OF CONDITION

PENCIL B PENCIL A

PICTURE PLANE AS SEEN BY OBSERVER

DIMINUTION — OBJECTS OF EQUAL SIZE APPEAR SMALLER AS THEIR DISTANCE FROM THE OBSERVER INCREASES. These pencils are both standing perfectly upright (but not directly in line with one another — if they were, the rear pencil would be overlapped and concealed). Pencil B appears smaller than pencil A. This is so because of the manner in which the lines of sight leading from eye to objects intersect (or "project" onto) the picture plane.

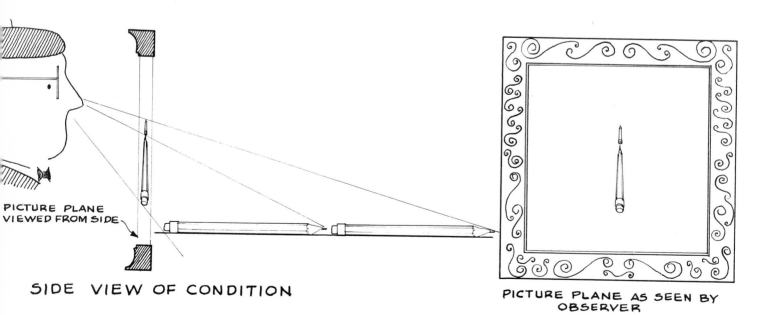

PICTURE PLANE VIEWED FROM SIDE

SIDE VIEW OF CONDITION

PICTURE PLANE AS SEEN BY OBSERVER

DIMINUTION — In this case, the pencils are lying in tandem on a table top, pointing away from the observer. Again the pencil furthest away appears and is drawn shorter. Why this is so is again explained by the way in which the lines of sight leading to each pencil intersect the picture plane.

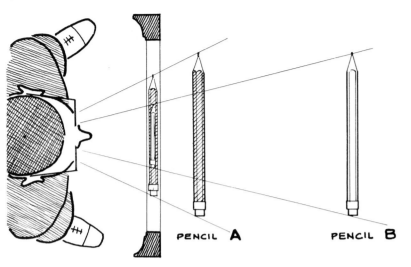

TOP VIEW OF CONDITION

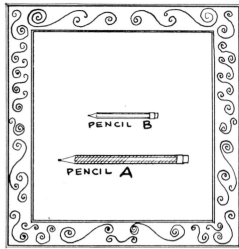

PICTURE PLANE AS SEEN BY OBSERVER

DIMINUTION: In this case, both pencils are again lying down, but parallel to the observer's face (*i.e.*, parallel to the picture plane). The foreground pencil would appear, and so is drawn, longer than the rear pencil. This is again explained by the lines of sight and their points of intersection with the picture plane. Study these lines. Suppose many more pencils were laid out in a similar manner. Would this not be identical with, and explain, the familiar phenomenon of the diminishing railroad cross-ties?

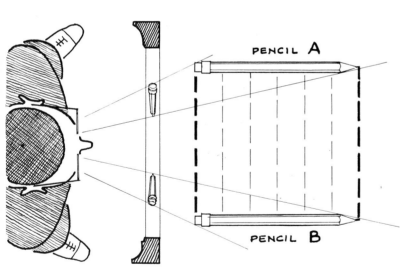

TOP VIEW OF CONDITION

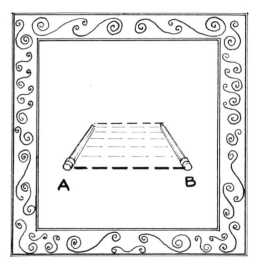

PICTURE PLANE AS SEEN BY OBSERVER

CONVERGENCE: PARALLEL LINES APPEAR TO APPROACH EACH OTHER AS THEY RECEDE. In this example, the pencils are lying parallel to one another, pointing away from the observer. They would appear to converge and are so drawn. Why this is so is again explained by the lines of sight. Those leading to the far ends of the pencils (the pointed ends) intersect the picture plane relatively close together. Those to the near ends (the eraser ends) intersect the plane further apart.

Another way of visualizing convergence is to think of it (as explained on page 3) as a result of diminution. So compare this drawing with the one above. Pencils in both diagrams are laid out to "define" perfect and equal squares. Therefore the dark dotted lines in the lower drawing could be the pencils of the diagram above and as such would be subjected to diminution as described above. In fact an infinite number of other parallel and equal lines (*e.g.*, the lightly dotted lines) will all diminish progressively, and their ends will trace out (or follow) the converging lines of the pencils.

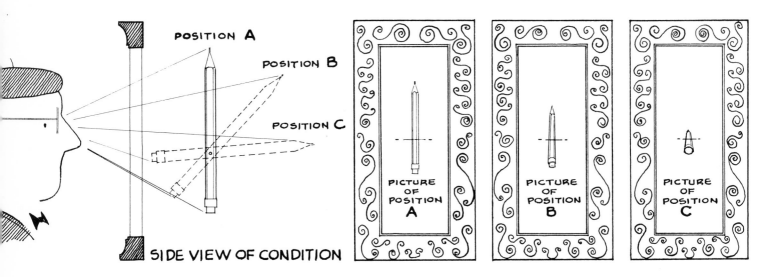

FORESHORTENING: LINES AND SURFACES ALWAYS APPEAR LONGEST WHEN PARALLEL TO THE OBSERVER'S FACE (*i.e.,* TO THE PICTURE PLANE). AS THEY REVOLVE AWAY FROM THIS POSITION THEY APPEAR INCREASINGLY SHORTER. Why this is so can be understood by noting how the lines of sight intersect the picture plane for each position of the pencil. (Note: when the pencil appears as a small circle, *i.e.,* when just the eraser or the pointed end is in view, then it is 100% foreshortened and aligned with the central visual ray.)

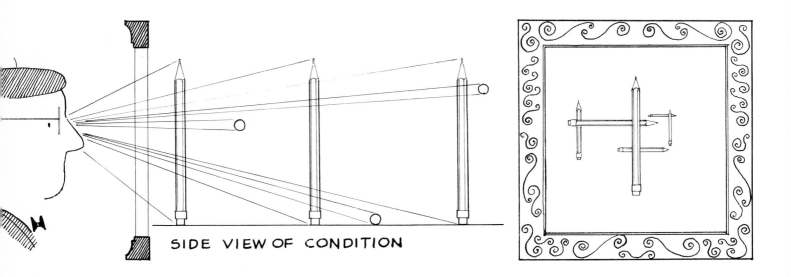

OVERLAPPING: This obvious technique must be emphasized because may beginners tend to avoid it.

It is based on the fact that lines of sight intercepted by an opaque object simply stop, so that objects beyond are partially or totally concealed (literally "blocked off"). The result is a strong sense of foreground and background planes, forwardness and beyondness, in other words, DEPTH.

Chapter 5: PRINCIPAL AIDS—VANISHING POINTS AND EYE LEVEL (HORIZON LINE)

In views of real life, and therefore in realistic pictures, the eye level (horizon line) is rarely visible, and vanishing points virtually never are. Yet the full significance of these concepts must be clearly understood. Working with an awareness of them and actually sketching them in temporarily are perspective drawing prerequisites.

AID No. 1: VANISHING POINTS

Any two or more lines that are in reality parallel will, if extended indefinitely, appear to come together or meet at a point. This point is called the VANISHING POINT of these lines.

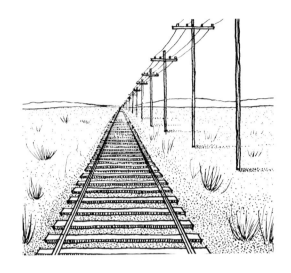

The classic and still best example of this phenomenon is the tracks of a railroad. The rails, in reality parallel, appear to converge and ultimately meet at a point in the distant horizon.

Many historical paintings of church interiors look something like this. If all the column capitals on each side, and then all the column bases, were "connected," and these lines "brought back" into the picture, they would meet at the same point as other similarly-oriented parallel lines such as the center aisle or the procession.

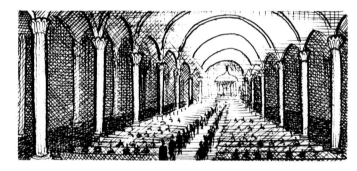

(The only exception to this occurs when the parallel lines are also parallel to the observer's face and to the picture plane. In this case, they neither recede nor converge and therefore do not have a vanishing point. For example, the edges of this brick wall and all its vertical and horizontal joints are exactly parallel to the observer's face and to the picture plane. Therefore, the verticals still appear vertical and the horizontals still appear horizontal and parallel to one another.)

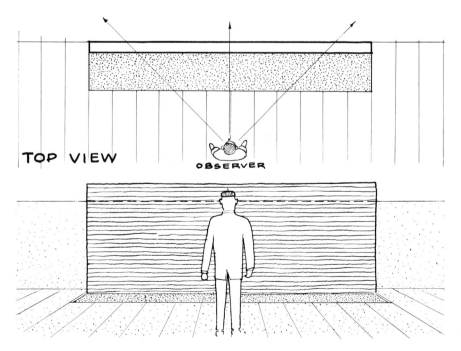

TOP VIEW OBSERVER

The general truth of seeing and drawing (except for the special case above) is: ALL LINES WHICH IN REALITY ARE PARALLEL WILL CONVERGE TOWARD A SINGLE VANISHING POINT.

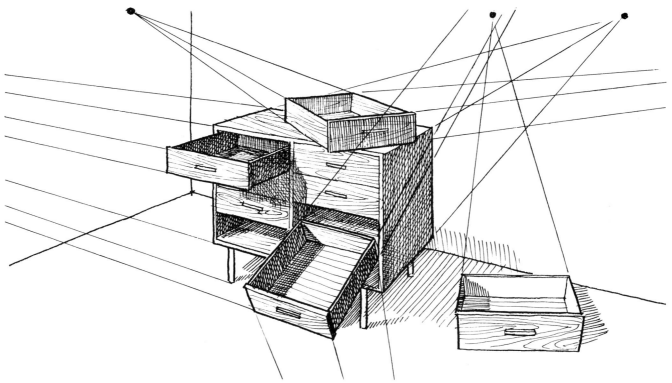

Take a photograph of a house (or of any other object with several sets of parallel lines) and with straight-edge and pencil extend the converging lines until they meet. Notice how the siding, window sills, etc., will converge in one direction, the door, louvers, etc., in another, and the sloped roof, shingles, etc., in still another. Each set of parallel lines, in other words, has its own vanishing point.

This slightly disorderly chest of draws has more sets of parallel lines than the house above and hence the drawing has more vanishing points. Notice that some exist far to the left or right of the picture and some (the tipped drawer) far above or below.

Therefore: REGARDLESS OF DIRECTION, EACH SET OF PARALLEL LINES WILL CONVERGE TOWARD ITS OWN VANISHING POINT. Check this for yourself in the professional examples across page.

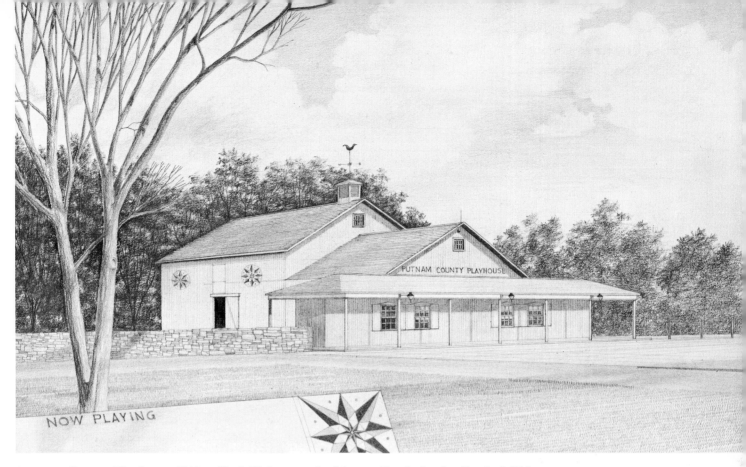

Putnam County Playhouse. D'Amelio & Hohauser, Architects. Rendering by Sanford Hohauser

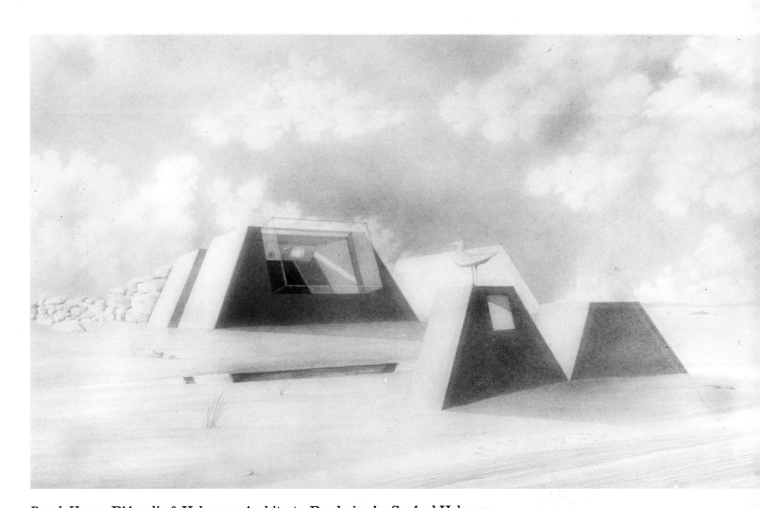

Beach House. D'Amelio & Hohauser, Architects. Rendering by Sanford Hohauser

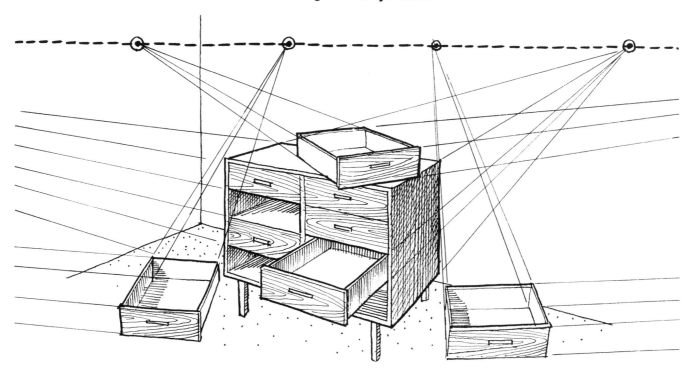

Take a suitable photo or drawing and extend all converging lines that are in reality horizontal (*i.e.*, parallel to the ground). Then connect the resulting vanishing points and notice how they all line up on a single horizontal line. This is the vanishing line for all converging horizontals.

Because our man-made environment consists primarily of shapes whose edges and markings approximate vertical and horizontal lines, this horizontal vanishing line plays a key role in perspective drawing.

What determines this line? . . . How is it used? . . . How does it affect drawings? . . .

All sets of horizontal parallel lines converge to points along the horizontal vanishing line.

Illustration courtesy of the Westinghouse Air Brake Company

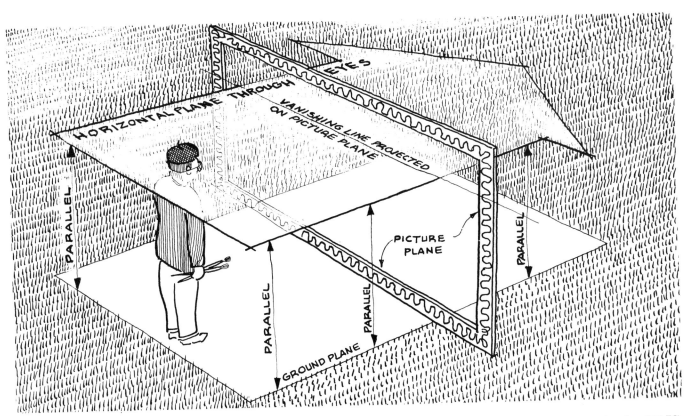

We've seen that this important line is straight and horizontal, but what determines its location? Very simply: IT IS AWAYS ON THE SAME LEVEL AS THE OBSERVER'S EYES. In other words, the observer's "eye level" — an imaginary plane at the level of the eyes and parallel to the ground — dictates the location (*i.e.*, the height from the ground) of the vanishing line for all horizontals in a given drawing.

A side view of the drawing above will show the eye level and the ground plane from their edges and therefore depict them as parallel horizontal lines. Here, the picture plane is also seen from its edge.

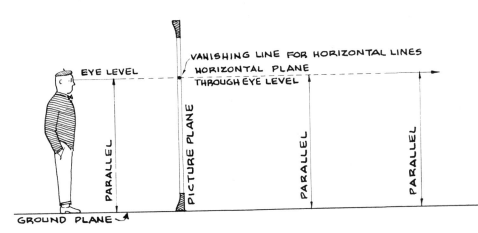

If we now look at the picture plane "front face" (as the observer views it) we again see the eye level plane in edge-on view — as a line. Here, though, the line also represents its projection onto the picture plane. Whether the observer jumped or kneeled, and so raised or lowered his eye level, this relationship would remain unchanged.

THEREFORE: THE EYE LEVEL NOT ONLY DICTATES BUT IS SYNONYMOUS WITH THE VANISHING LINE FOR HORIZONTAL LINES.

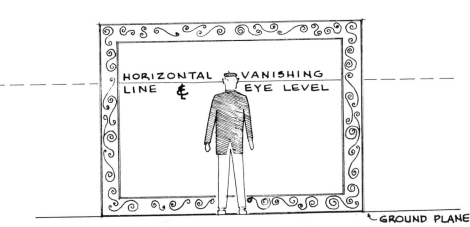

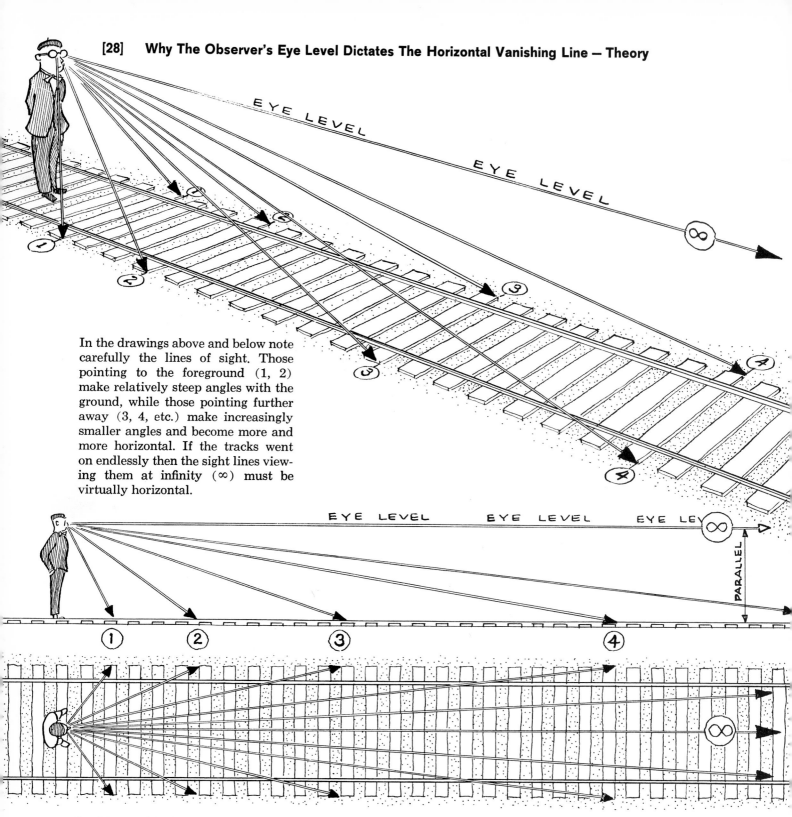

In the drawings above and below note carefully the lines of sight. Those pointing to the foreground (1, 2) make relatively steep angles with the ground, while those pointing further away (3, 4, etc.) make increasingly smaller angles and become more and more horizontal. If the tracks went on endlessly then the sight lines viewing them at infinity (∞) must be virtually horizontal.

Looking at this situation from above, we note that the lines of sight embracing the width of the foreground ties depart from the observer at a wide angle, and that this angle gets progressively smaller for sight lines to ties progressively further away. We can therefore conclude that at infinity this angle is so infinitesimal that a single sight line can be used. In that case we would "see" a 7-ft.-wide cross-tie by means of a single sight line; total diminution would have occurred and only a point would appear on the picture plane. This point, of course, is the vanishing point of the tracks.

Now look at the side view again and note that this same single sight line pointing to infinity (∞) is horizontal (*i.e.*, parallel to the ground). *Therefore the vanishing point of the tracks must be at the observer's eye level.*

In fact, all horizontal lines, if extended indefinitely like the railroad tracks, would appear to converge to a point at the observer's eye level.

SO IT IS ACCURATE AS WELL AS USEFUL TO THINK OF THE EYE LEVEL AS THE VANISHING LINE FOR ALL HORIZONTAL LINES AND PLANES.

This is what our observer sees. His eye level is the vanishing line for horizontal lines. (Actually, it is a plane seen edge-on.)

But what located the specific vanishing point? Across page we saw that the horizontal sight line aimed at infinity parallel to the tracks points to it. So, very simply: *the vanishing point of the tracks is the point at which the sight line parallel to them intersects the picture plane.* (The vanishing point essentially *is* this horizontal sight line seen from its end.) All lines parallel to the tracks will naturally also converge toward this same point.

IN OTHER WORDS THE OBSERVER SIMPLY "POINTED" WITH HIS EYES PARALLEL TO THE GIVEN SET OF LINES IN ORDER TO LOCATE THEIR VANISHING POINT.

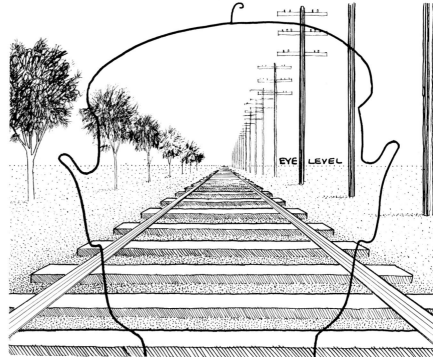

The following will show that this holds true *regardless of the direction of the set of lines.*

Here the tracks are at an angle to the picture plane.

The side view across page again applies, so we know that the infinite point of convergence (vanishing point) must be at eye level.

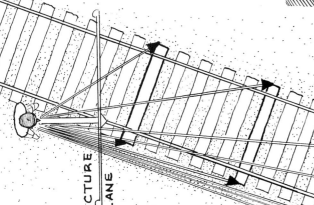

Now, looking at this new top view, we see that sight lines embracing the width of the foreground ties depart, as before, at a wide angle. For ties further away this angle gets progressively smaller and also aims more and more to the right. When the ties are finally viewed at infinity only a single sight line remains and it is virtually parallel to the tracks. Therefore, the sight line parallel to the tracks "points" to the tracks' vanishing point.

This little experiment would work for ANY set of parallel lines that appear to converge, regardless of whether they were horizontal, vertical or oblique, or whether the observer were looking up at them, straight out or down. Therefore the universal rule is: *The vanishing point for any set of parallel lines is the point at which the sight line parallel to the set intersects the picture plane.*

IN OTHER WORDS THE OBSERVER SIMPLY POINTS IN THE SAME DIRECTION AS THE LINES IN ORDER TO FIND THEIR VANISHING POINT.

[30] Why The "Parallel Pointing" Method Of Locating Vanishing Points Is Important

In T-square and triangle perspective, this method of locating vanishing points is an essential step.

Thus, to draw the object below, we first construct a top view or plan (*left*), showing the object, the picture plane (seen as a line) and the observer's position. On this plan, "sight lines" pointing parallel to the object lines are drawn to locate the vanishing points on the picture plane. Other sight lines "project" the object itself onto the picture plane. The picture plane line, therefore, shows the relationship of the object's apparent size to the vanishing points. This "measurement line" is then transferred to the actual picture (*right*), where it is superimposed on the horizontal vanishing line (eye level). Whether the subject is now drawn above, below, or straddling this line, the relationships remain the same.

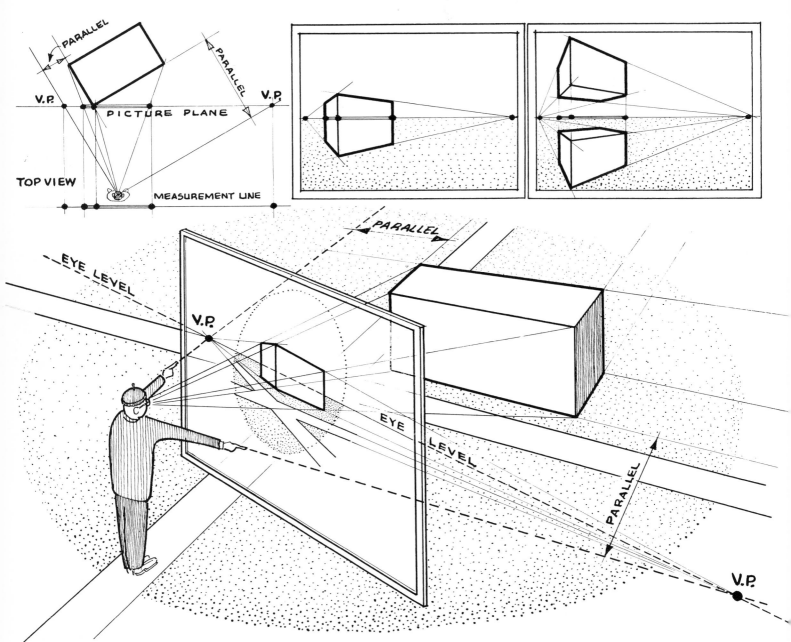

In freehand drawing, whether from life or from imagination, this procedure naturally is inapplicable. The convergence of lines, foreshortening, etc., must instead be determined by careful observation or visualization.

Yet in this book the figure of an observer pointing toward a picture plane parallel to object lines will be shown repeatedly, in order to emphasize the importance of the observer-to-subject relationship even for freehand drawing.

The observer's viewpoint and cone of vision, his distance from a subject, and the apparent direction of the subject's lines are the principal determinants of how things appear in real life and therefore in perspective drawing. As these factors change, so will the picture. This is the key to any "system" of perspective drawing. Becoming aware of it and understanding it will strengthen your powers of visualization and observation.

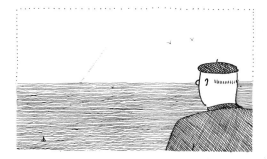

In other words, if the observer is on a mountain top or descending in a parachute the horizon line will appear on a level with his eyes.

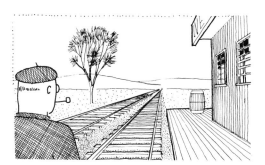

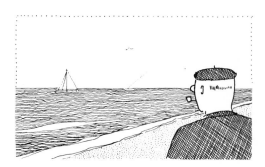

And when the observer is on flat ground the horizon line will *still* appear at his eye level. (In this case, though, notice that the amount of ground before him seems less than the amount seen from the higher level.)

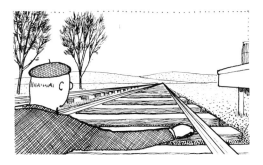

And if the observer lies on the ground the horizon line will *still* appear at eye level. (But notice that here the amount of ground area leading to the horizon line seems even less than in the above two views.)

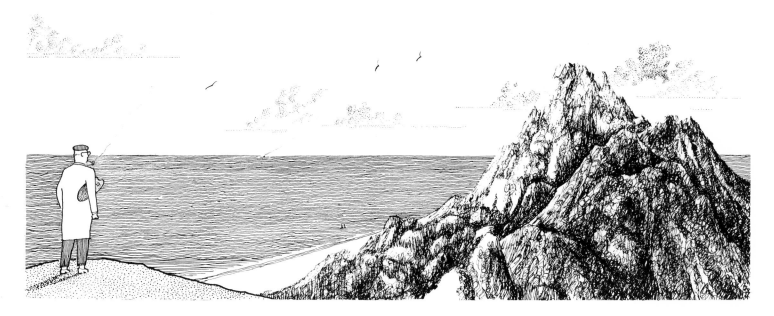

In fact, nature's horizon line, whether visible or concealed (by these mountains, for instance, or by a house, trees or people), will always be at the observer's eye level. The eye level, we have seen, is the vanishing line for all horizontal lines. Therefore, this line, which is both eye level and nature's horizon, is of great importance, for on it are located the vanishing points of all sets of horizontal lines.

NATURE'S HORIZON LINE: (*i.e.*, where the sky appears to meet the ocean, prairie, or desert) is technically slightly different from observer's eye level. The eye level plane is truly horizontal (*i.e.*, constantly perpendicular to the line of the observer's body) while the earth actually curves away from the observer in all directions. The diagram shows this, but with tremendous exaggeration.

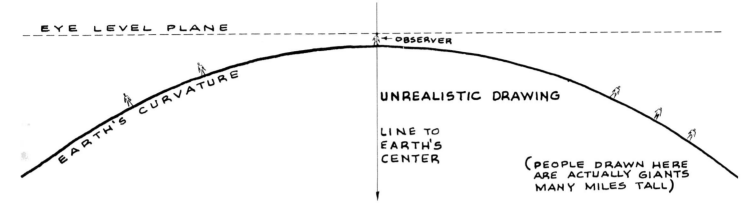

EYE LEVEL PLANE

← OBSERVER

EARTH'S CURVATURE

UNREALISTIC DRAWING

LINE TO
EARTH'S
CENTER

(PEOPLE DRAWN HERE
ARE ACTUALLY GIANTS
MANY MILES TALL)

If this "cut" through the earth were drawn correctly with the eye level close to the ground and the earth's curvature drawn to scale, the diagram below would result. The earth's curvature is so infinitesimal for most observable distances that it can be disregarded. The earth's surface and observer's eye level would therefore be virtually parallel.

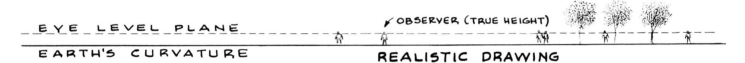

EYE LEVEL PLANE

OBSERVER (TRUE HEIGHT)

EARTH'S CURVATURE

REALISTIC DRAWING

Thus, the diagrams on pages 28 and 29, showing a flat ground plane parallel to observer's eye level, are realistic and the conclusions drawn from them are valid. In fact, artists have for ages, and in every field of fine and applied art, used the concepts "eye level" and "nature's horizon line" interchangeably. In practical terms, this means that as the observer's eye level is raised or lowered, nature's horizon line always accompanies it and appears at the same horizontal level. It also means that a painting or drawing which shows any part of nature's horizon immediately indicates the artist's eye level and his relationship to the subject.

In the illustration below, therefore, the observer's eyes were exactly level with the picture's "center of interest." Note that both the horizon line and the line of the dune point to it.

Painted by William A. Smith for *Redbook Magazine*

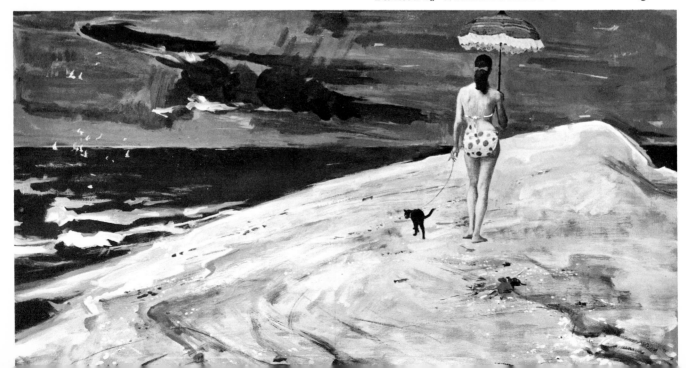

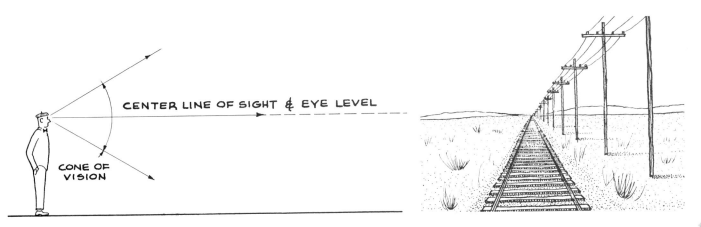

LOOKING STRAIGHT OUT. Here, the central visual ray points horizontally (parallel to the ground). It therefore lies exactly on the eye level plane. Because the cone of vision is symmetrical around this central ray, the observer sees as much above eye level as below. In the picture, consequently, the eye level (horizon line) is midway between top and bottom.

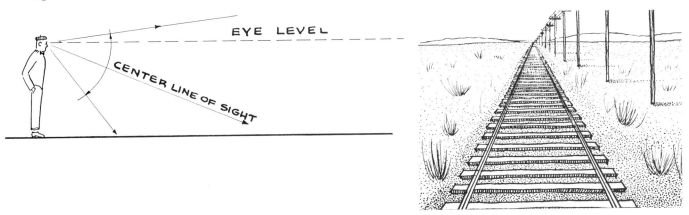

LOOKING DOWN. Here, the central visual ray points not at the distant horizon but down at the tracks. The cone of vision, therefore, just barely includes the eye level plane. (Note the proximity of top sight lines and eye level.) In the picture, therefore, the eye level (horizon line) is close to the top.

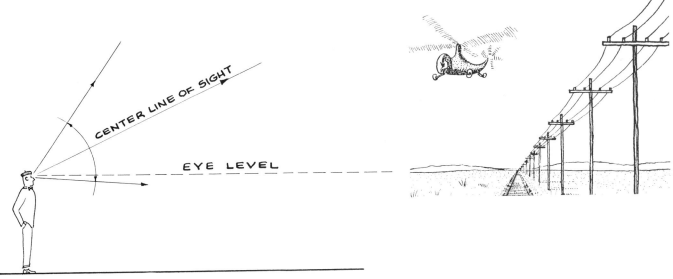

LOOKING UP. Here, the central visual ray points at something in the sky or at the top of a telegraph pole. The cone of vision barely "sees" the eye level plane with its lowest sight lines. In the picture therefore, the eye level (horizon line) is close to the bottom.

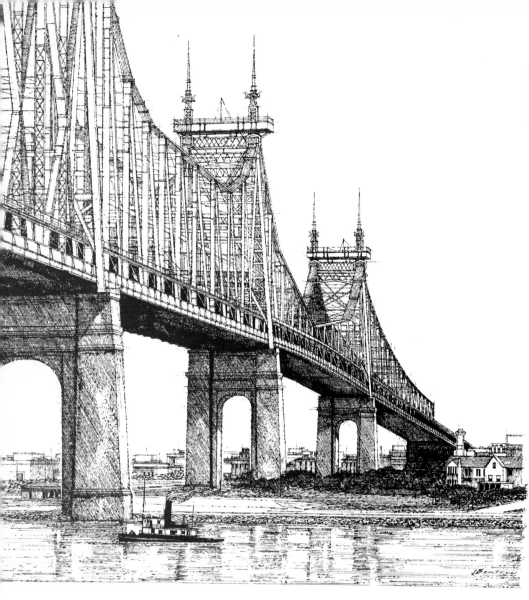

An example of "looking up." The horizon line (eye level) is low in picture.

Drawing by Joseph Bertelli for the Long Island City Savings Bank

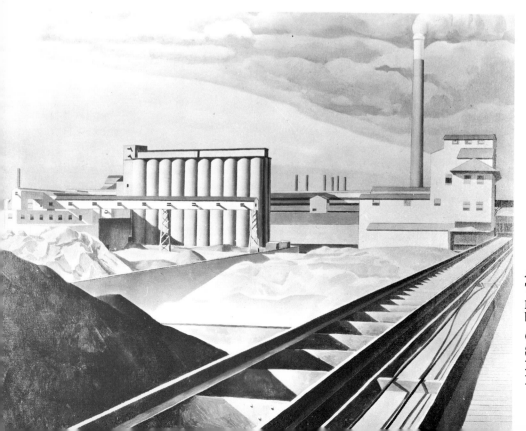

An example of "looking straight out." The horizon line (eye level) is approximately midway between top and bottom of picture.

Classic Landscape, by Charles Sheeler. Courtesy of Mrs. Edsel B. Ford and Museum of Modern Art, N.Y.

In extreme cases the eye level (horizon line) is completely above or below the drawing. The sketches below indicate, respectively, that you are looking downwards and upwards at still steeper angles than before.

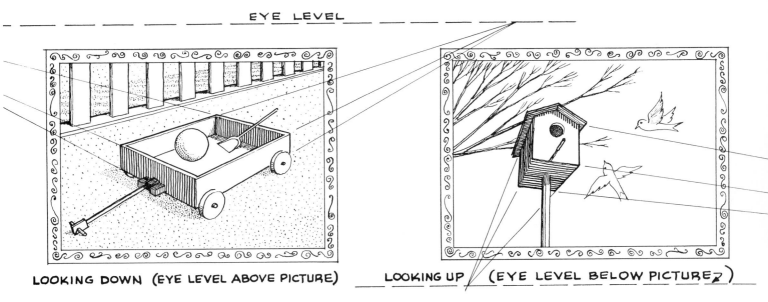

LOOKING DOWN (EYE LEVEL ABOVE PICTURE) LOOKING UP (EYE LEVEL BELOW PICTURE)

So while it may be obvious that when you look up you see more sky or ceiling, and when you look down you see more ground or floor, what is not quite so obvious is that the eye level-horizon line (always on a horizontal plane through the observer's eyes) shifts up and down *inversely*.

Therefore, if, when you start a drawing, you place the eye level (horizon line) high on the canvas or sheet, you *must* be looking down on the subject; if you place it midway, you *must* be looking out horizontally (the central visual ray is approximately on the eye level plane); and if you place it along the bottom you *must* be looking up at the subject. This holds true whether drawing or painting from life or from imagination. Try it and see.

So bear in mind: any drawing which shows or suggests its eye level-horizon line invariably indicates the artist's direction of sight and whether the subject was viewed from above or below, or head-on.

Below: An example of "looking down." The horizon line (eye level) is above the picture. *National Cowboy Hall of Fame and Memorial Museum,* Oklahoma City. (Second award, National Competition for Architectural Commission.) Joseph D'Amelio, Architect and Renderer

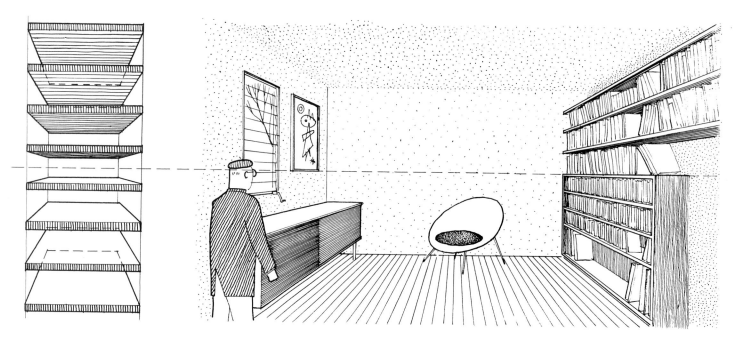

Some factors in making this choice are: Horizontal planes will show their undersides when above eye level, and their tops when below.... At eye level they foreshorten altogether and appear as simple lines.... Also, all converging horizontal lines or planes will tend downwards when above eye level and upwards when below.... At eye level they appear perfectly horizontal (so when you look at a drawing that does not show nature's horizon line, you can find eye level by noting the receding horizontal line or plane that still appears horizontal — *e.g.*, the top of the bookcase).

Object depicted below eye level in order to see top.

Object depicted above eye level in order to see underside.

Another reason for choosing a particular eye level is the nature of the subject being depicted. Some things are typically seen from above (*e.g.*, furniture) others are typically seen from below (*e.g.*, airplanes). Drawing a subject from its most common viewpoint helps to express its function.

Because so much of what we see in life is seen by looking straight out you'll find that in the vast majority of drawings the eye level (horizon line) is within the picture.

Chapter 6: DRAWING THE CUBE – PREREQUISITE TO UNDERSTANDING PERSPECTIVE

Drawing the simple cube (or any rectangular prism such as a brick, a book or the U.N. Secretariat) from many viewpoints is an important exercise which reveals and explores basic perspective principles. The following pages dramatize many of these. But these studies can only point to the problems involved and help to stimulate your powers of observation. To draw properly you must supplement them with intensive sketching and observation of your own. Get into this habit.

The six sides of a cube (or any rectangular prism) are "edged" by three sets of parallel lines. When the cube rests on a horizontal surface, such as a table top, one set of lines is vertical (*i.e.*, perpendicular to the ground), the other two sets are horizontal (*i.e.*, level with the ground) and at right angles to each other.

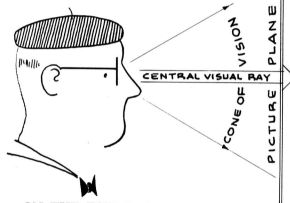

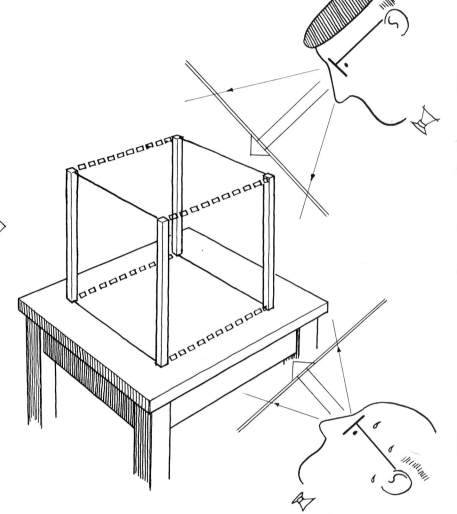

ON THE FOLLOWING PAGES:

— VERTICALS WILL BE INDICATED BY PIPES

— ONE SET OF HORIZONTALS WILL BE INDICATED BY CHAINS

— THE OTHER SET OF HORIZONTALS WILL BE INDICATED BY WIRES

NOW A QUICK REVIEW: We see things, as shown on pages 18 and 19, by means of a *central visual ray* surrounded by a *cone of vision*. The central visual ray focuses upon the center of interest, while the cone of vision defines the roughly circular area within which we can see things clearly. Perpendicular to the central visual ray is the *picture plane,* which may be thought of as a piece of glass or the drawing paper or canvas itself. The observer's face will also be considered perpendicular to the central visual ray, hence always parallel to the picture plane. Keep this schema in mind.

Also recall the following points:

Lines and planes parallel to the observer's face (and consequently to the picture plane) undergo no distortion, but maintain their true directions and shapes.

Lines and planes which are *not* parallel to the observer's face (picture plane) appear to converge and foreshorten. (Such lines are sometimes described as "receding.")

The vanishing point for any set of receding parallel lines is the point at which the observer's sight line parallel to the set intersects the picture plane. To locate this point, the observer merely "points" in the same direction as the lines.

THE DIAGRAMS ON THE NEXT SEVERAL PAGES ARE BASED ON THESE FUNDAMENTAL PRINCIPLES.

(In the following examples you can either think of the observer as walking around the cube, or of the cube as revolving. The results are identical.)

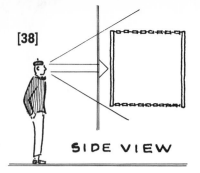

SIDE VIEW

Looking Straight Out At The Cube

The pipes are parallel to face (and picture plane), so in all views they appear as true verticals. The vanishing points for horizontals must be at eye level (which is also in this case the plane of the central visual ray). The top views below show the method of locating these points.

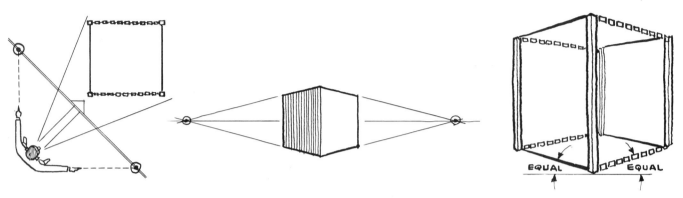

The chains and wires converge and foreshorten. Their vanishing points are equidistant from the cone of vision in top view. Therefore they are equidistant from cube in picture. Note equal angles.

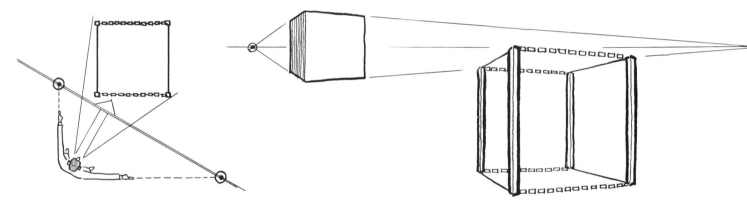

Again both sets of horizontal lines converge and foreshorten. But since observer's right arm points further away, the right vanishing point is more distant. (*See example across page.*)

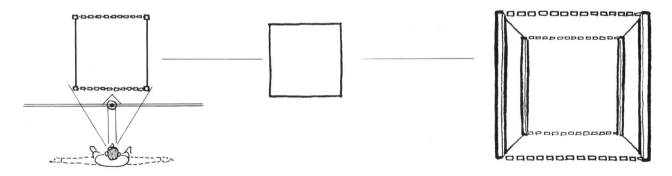

In this case, only the wires are oblique to the picture plane (actually, they are perpendicular to it) and therefore they alone converge. The central visual ray itself points to their vanishing point. (*See example across page.*)

NOTE: The vanishing points are closest to each other when the two front vertical surfaces of the cube make equal angles with observer, *i.e.,* when observer looks exactly at a corner (*top of page*). They spread apart as one surface draws parallel to observer's face and the other foreshortens (*center of page*). Finally (*bottom diagram*), they are an infinite distance apart.

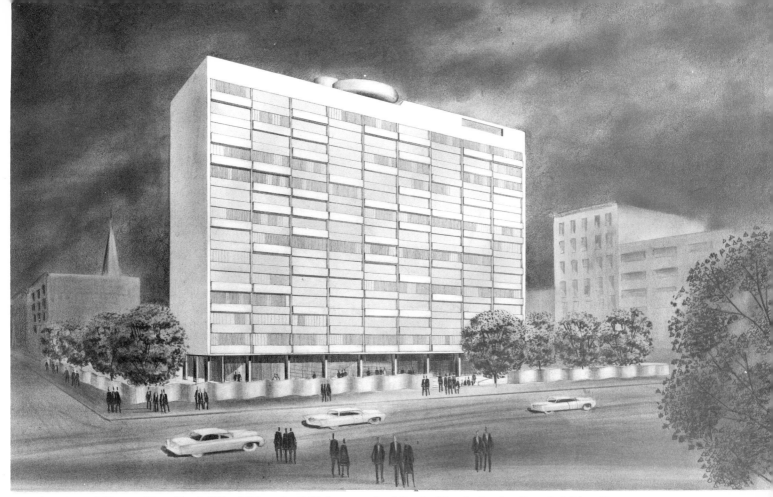

Apartment House, New York City. D'Amelio & Hohauser, Architects. Rendering by Joseph D'Amelio

Medical Clinic Entrance. D'Amelio & Hohauser, Architects. Rendering by Joseph D'Amelio

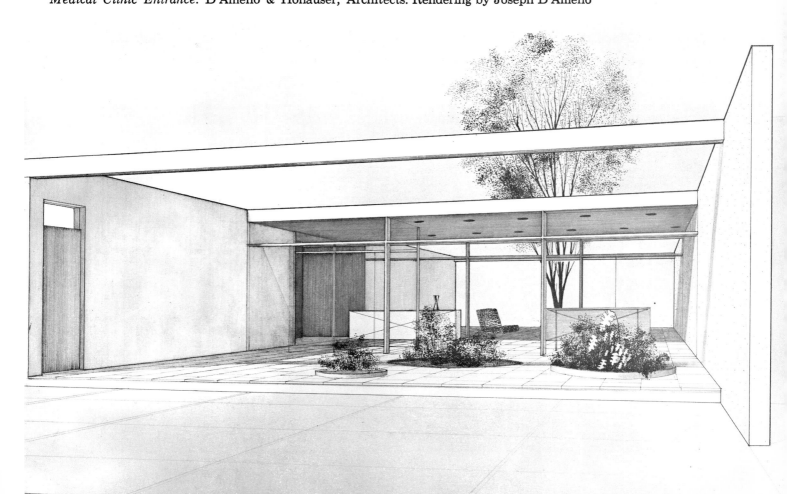

Looking Down At The Cube

The pipes are no longer parallel to observer's face (and picture plane) so they also converge and foreshorten. Their vanishing point on picture plane is located by pointing downwards in their direction.

The vanishing points for horizontals must be on the eye level-horizon line (pointed to by other arm). The manner in which a pointing observer locates them on this line is again shown in the different top views.

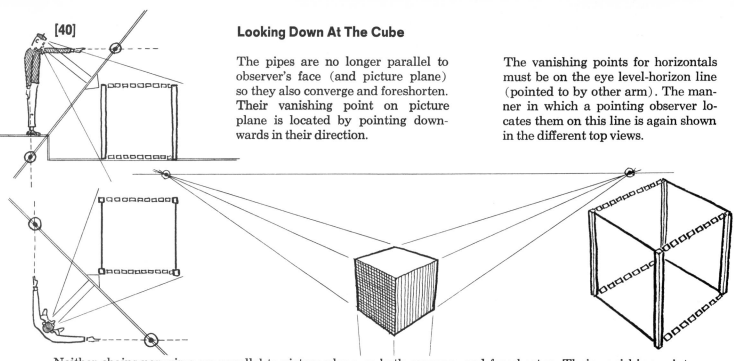

Neither chains nor wires are parallel to picture plane, so both converge and foreshorten. Their vanishing points are equidistant from picture because both pointing arms are equidistant from cone of vision.

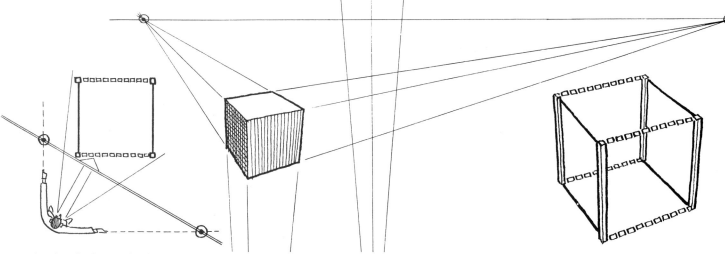

Again, chains and wires are oblique to picture plane, so both converge and foreshorten. The chains' vanishing point is further away because the pointing right arm is further from the cone of vision.

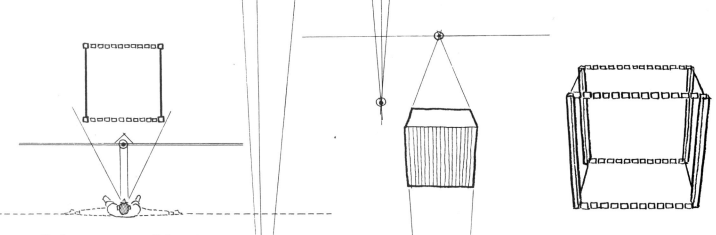

Chains are now parallel to picture plane so they appear parallel and horizontal. (If observer pointed in their direction (*dotted lines*) he would never intersect the picture plane.) Wires are not parallel to the picture plane. A sight line parallel to the wires (located directly above the central visual ray) points to their vanishing point on eye level.

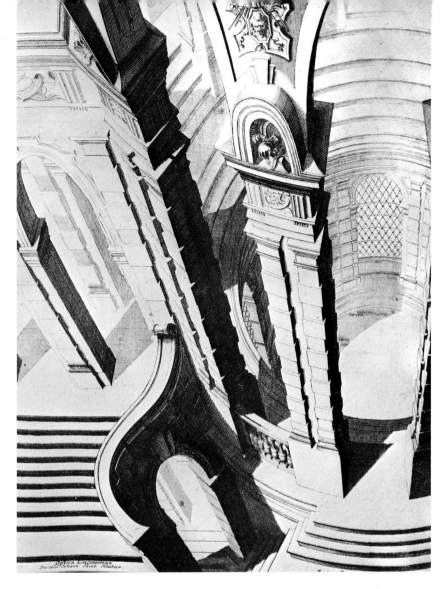

Two examples of "looking down." Note the downward convergence of vertical lines.

18th-century drawing by Johann Schubler. Courtesy of The Cooper Union Museum, New York City

Midnight Ride of Paul Revere, by Grant Wood. The Metropolitan Museum of Art. Courtesy of Associated American Artists

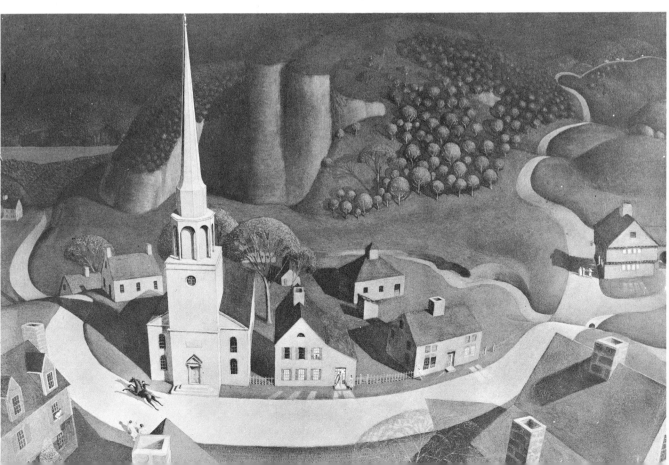

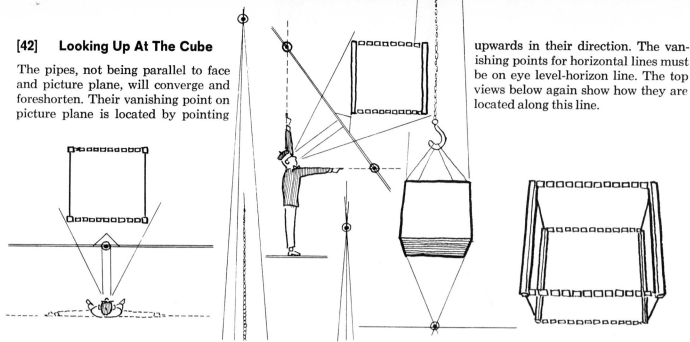

[42] Looking Up At The Cube

The pipes, not being parallel to face and picture plane, will converge and foreshorten. Their vanishing point on picture plane is located by pointing upwards in their direction. The vanishing points for horizontal lines must be on eye level-horizon line. The top views below again show how they are located along this line.

Chains are parallel to picture plane so they remain parallel and horizontal. (Try pointing toward their vanishing point.) Wires are not parallel to picture plane; a horizontal sight line parallel to the wires (located directly below the central visual ray) points to their vanishing point on eye level.

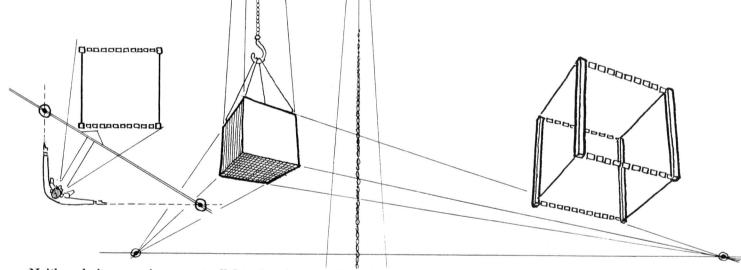

Neither chains nor wires are parallel to the picture so both converge and foreshorten. The chains' vanishing point is further away because the pointing right arm is further from cone of vision.

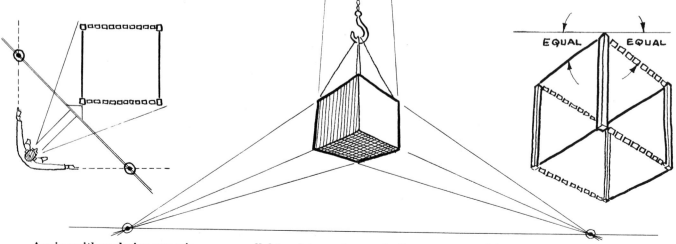

Again neither chains nor wires are parallel to picture plane so both converge and foreshorten. Their vanishing points are equidistant from picture because observer's arms are equidistant from cone of vision. Note equal angles which result when "looking at corner."

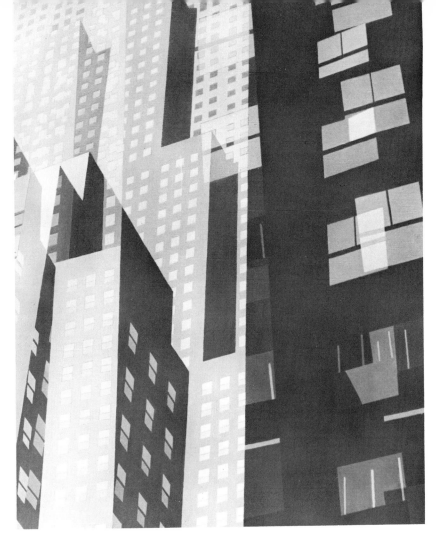

Two examples of "looking up." Note the upward convergence of vertical lines.

Windows, by Charles Sheeler. Courtesy of the Downtown Gallery, N. Y.

(Below) Painted by Austin Briggs for McCalls magazine

Now let's look again at the U.N. buildings. Each view results in a different type of convergence and foreshortening. Each should be referred back to the cube drawing of similar viewpoint.

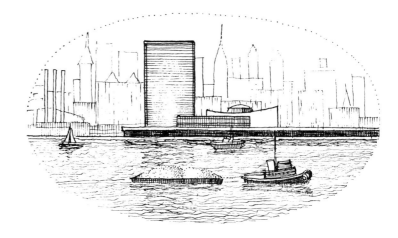

Observer is across the river at ground level, looking straight ahead. (*See page 38, bottom.*)

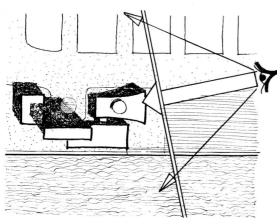
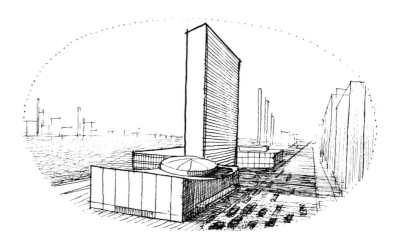

Observer is now in Manhattan, still looking straight ahead and still at a distance. (*See page 38, center.*)

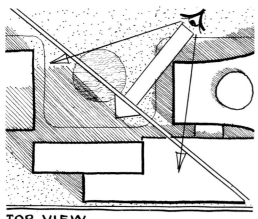
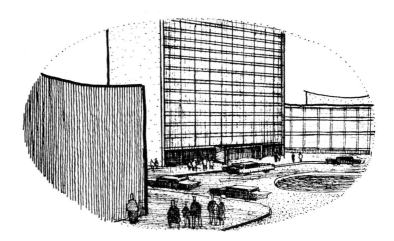

Observer is much closer but still looking straight ahead. (*See page 38, center.*)

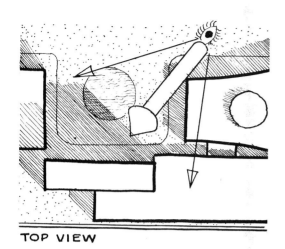

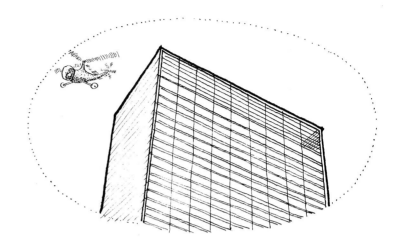

TOP VIEW

Observer is at same position but is now looking up. (*See page 42, center.*)

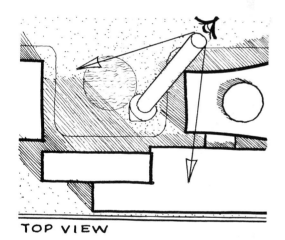

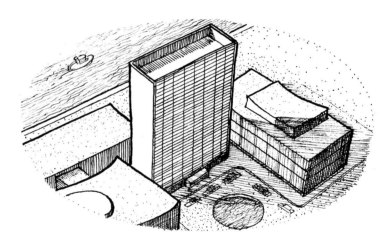

TOP VIEW

Observer is now in helicopter looking down. (*See page 40, center.*)

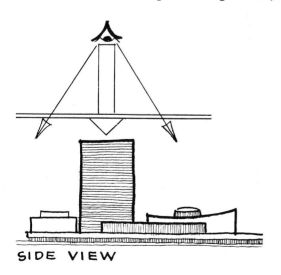

SIDE VIEW

Observer is still in helicopter but now looking straight down at Secretariat Building. (*Compare with page 38, bottom.*)

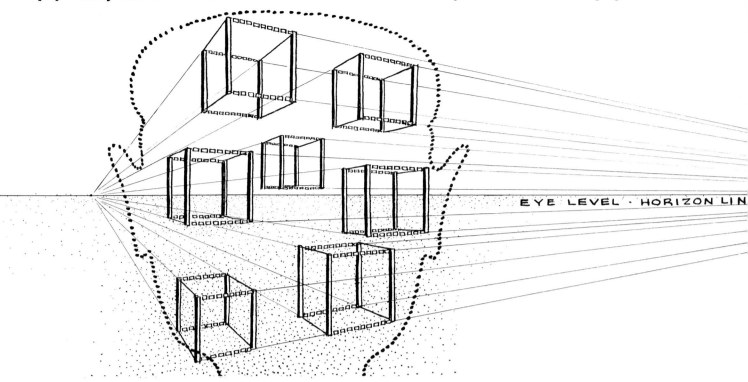

EYE LEVEL · HORIZON LIN

Here, many parallel cubes, above and below eye level, are viewed simultaneously (within one cone of vision). Therefore the chains (all horizonal and parallel) will converge toward one vanishing point, and the wires (horizontal and parallel, but going in a different direction) will converge toward a different vanishing point. The pipes, being parallel to the observer's face, will remain parallel.

Note that wires and chains above eye level converge downwards, while those below eye level converge upwards. (If any were exactly on eye level they would naturally appear horizontal.)

These simple principles are evident in the perspective rendering shown below.

Project for Hill City Inc. D'Amelio & Hohauser, Architects. Rendering by Joseph D'Amelio

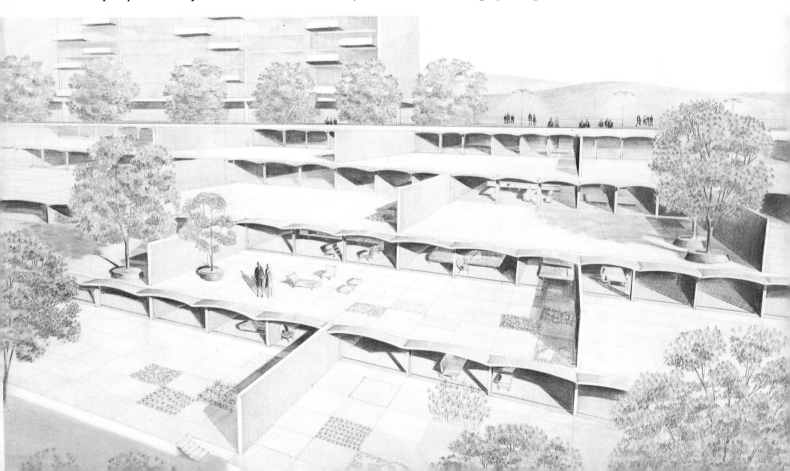

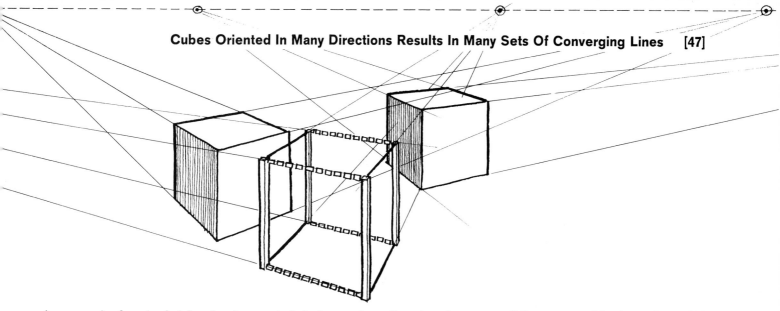

A group of cubes (or bricks, dominoes, etc.) facing various directions has many different sets of horizontal parallel lines. Each set, if extended, would appear to converge to its own vanishing point on the horizon line (eye level). Below are applications of this principle.

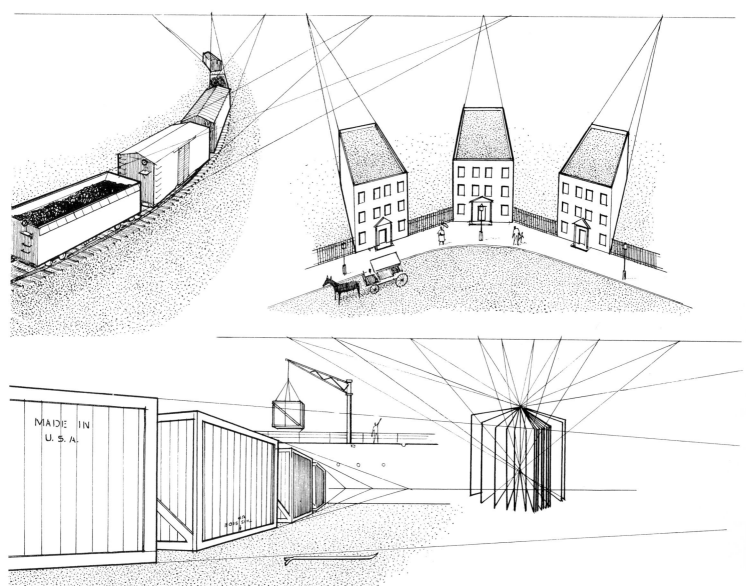

GENERAL RULE: WHEN THERE ARE MANY SETS OF PARALLEL HORIZONTAL LINES, EACH SET WILL CONVERGE TOWARD ITS OWN VANISHING POINT ON THE HORIZON LINE (EYE LEVEL).

ONCE A BASIC SHAPE SUCH AS A CUBE OR A RECTANGULAR PRISM IS DRAWN CORRECTLY IT CAN BECOME THE GUIDE FORM FOR A WIDE VARIETY OF OBJECTS.

THE SIZE OF THE OBJECT DOES NOT MATTER. FOR INSTANCE, A PRISM OF THIS PROPORTION (*below*) DRAWN AT THIS ANGLE COULD BECOME A BOOK, AN OFFICE BUILDING, OR EVEN A BILLBOARD.

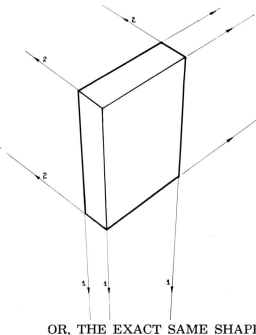

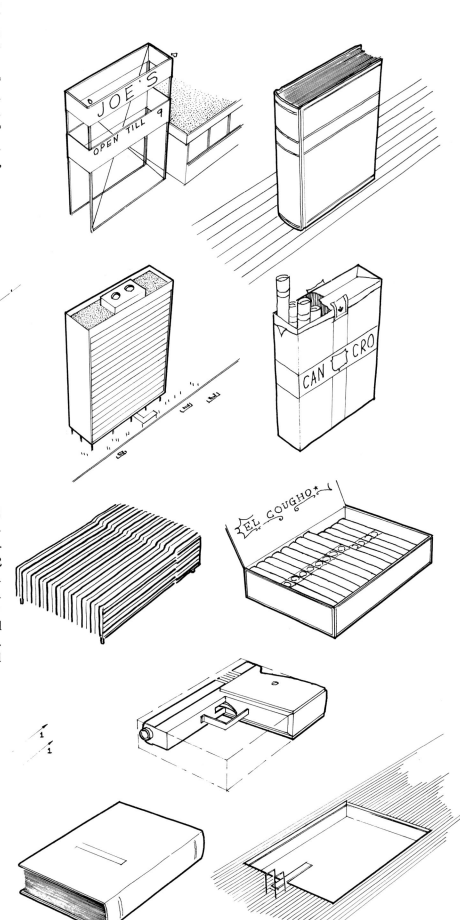

OR, THE EXACT SAME SHAPE COULD BE "LAID DOWN" TO BECOME A "PACKAGE" FOR HORIZONTAL OBJECTS OF SIMILAR PROPORTIONS, *e.g.*, A BED, A CIGAR BOX, A GUN, A BOOK, A SWIMMING POOL, ETC. (Note: Lines #2 which previously converged to the left now converge downwards. Lines #1 which previously converged downwards now converge to right.)

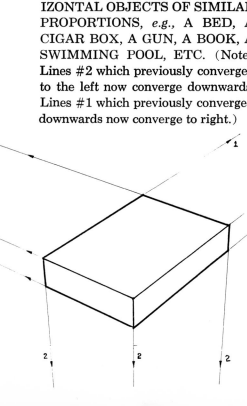

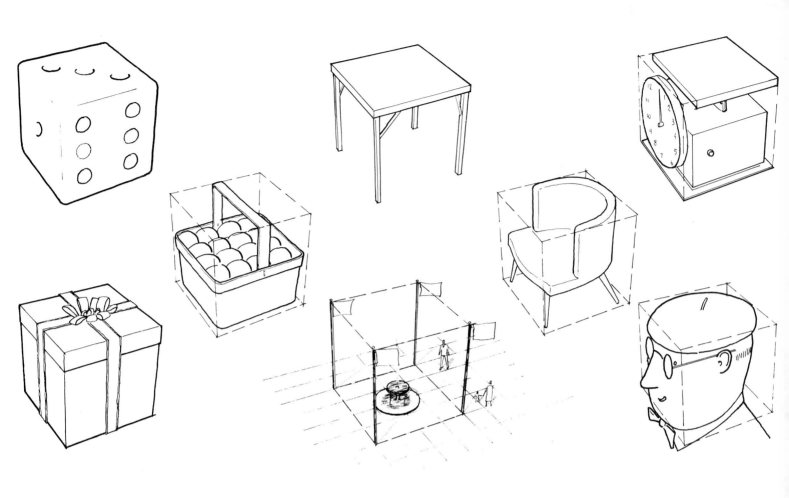

And So Can The Basic Brick Shape — Look Around And See

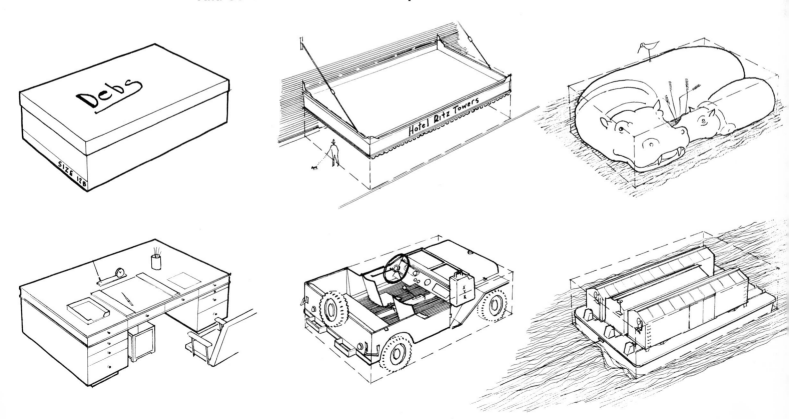

Chapter 7: "ONE-POINT" AND "TWO-POINT" PERSPECTIVE— WHEN AND WHY?

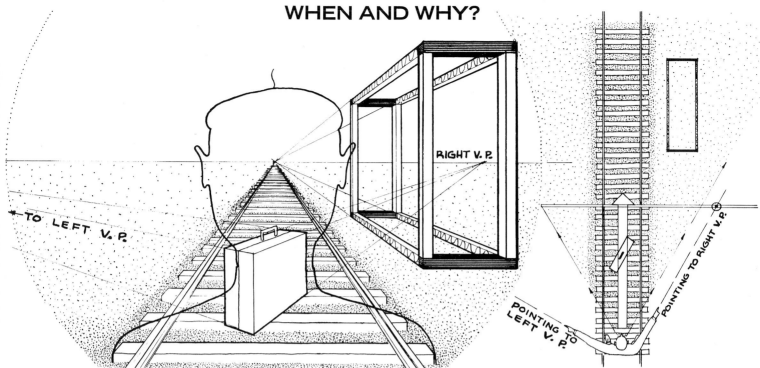

The ties of the railroad and the black lines of the structure at the right are parallel to the picture plane; therefore they do not converge. The rails and the fancy lines of the structure are perpendicular to the picture plane; therefore they do converge, and since the observer's central visual ray points exactly in their direction, their vanishing point must be in the center of the picture. This is one-point perspective. Now look at the suitcase. Both sets of its horizontal lines are oblique to the picture plane; therefore they converge to left and right. The observer (top view) points in their direction to locate their vanishing points. This is two-point perspective.

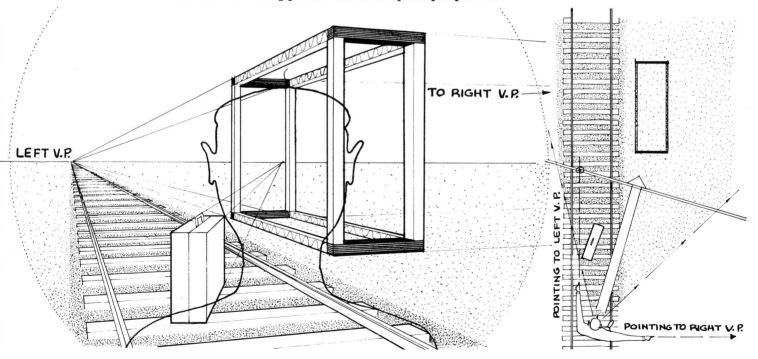

When the observer shifts his attention to the structure, the railroad ties and black lines become oblique to the picture plane, as do the rails and the fancy lines of the structure, in another direction. In the top view, the observer's right hand points to the vanishing point of the first set of lines, while his left hand points to the vanishing point of the second. Now consider the suitcase: one horizontal set of lines has become perpendicular to the picture plane. Therefore the central visual ray points to its vanishing point, which must be in the center of the picture. The other set of suitcase lines is parallel to the picture plane; so the lines remain parallel in the drawing. The one- and two-point perspectives have been transposed.

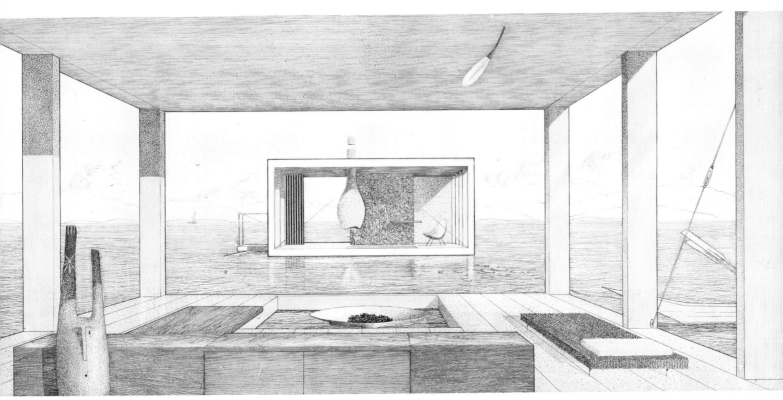

Floating Houses, Lake George, N. Y. D'Amelio & Hohauser, Architects. An example of "one-point" perspective with the point correctly placed at the center of picture. Rendering by Sanford Hohauser

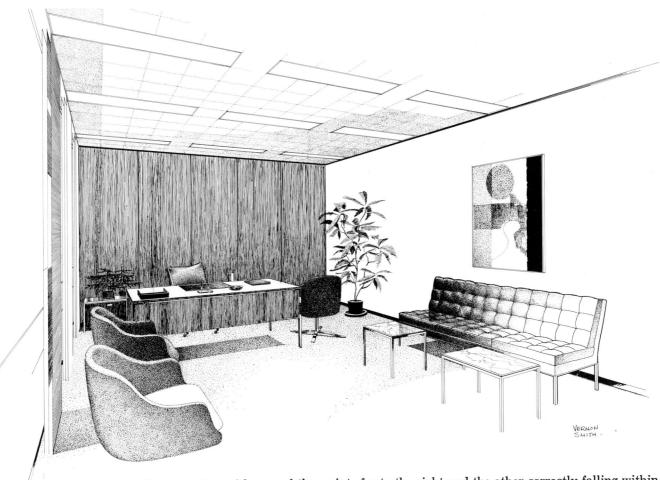

An example of "two-point" perspective with one of the points far to the right and the other correctly falling within the picture. Rendering by Vernon Smith

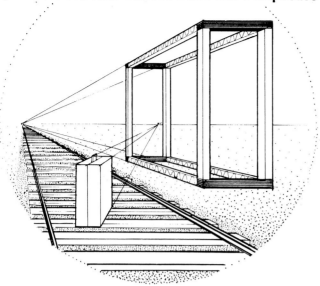

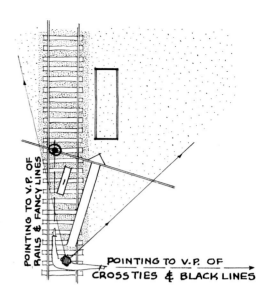

POINTING TO V.P. OF
RAILS & FANCY LINES

POINTING TO V.P. OF
CROSS TIES & BLACK LINES

Many books state categorically that when the vanishing point of one set of horizontal lines of a rectangular subject (such as a railroad track, a cube, etc.) falls within the picture then the other set of lines (at right angles) does not converge and the lines remain parallel and horizontal. The picture above is based on this arbitrary rule.

Note that the rails and the fancy lines converge to their correct vanishing point but that the cross-ties and black lines, which are also oblique to the picture plane (*see top view*) and should converge to the vanishing point indicated by the observer's right arm, do not. What about the suitcase? Its receding set of lines correctly vanishes to the point indicated by the central visual ray, while the set parallel to the picture plane remains, also correctly, horizontal and non-convergent. The result is that the front edge of the suitcase comes out parallel to the cross-ties. This surely is wrong! Also, it's obvious that objects at the far right suffer from distortion. In other words this rule is contrary to basic perspective drawing principles and results in a variety of distortions and inaccuracies.

The reason this rule prevails is that it eliminates the difficulty of working with distant vanishing points. But while this difficulty may complicate T-square and triangle perspective, it surely is no problem in freehand work.

Therefore, when the vanishing point of one set of lines of a rectangular object is placed at the vertical center of a drawing then the other set of lines (at right angles) should appear parallel and horizontal. (E.g., *top picture previous page.*) But when this one vanishing point shifts away from the center, indicating that the observer is shifting his viewpoint, *the other set of lines should begin to converge to a distant vanishing point.* (E.g., *bottom picture previous page and picture below.*)

Long Island Savings Bank, D'Amelio & Hohauser, Architects. Rendering by Joseph D'Amelio

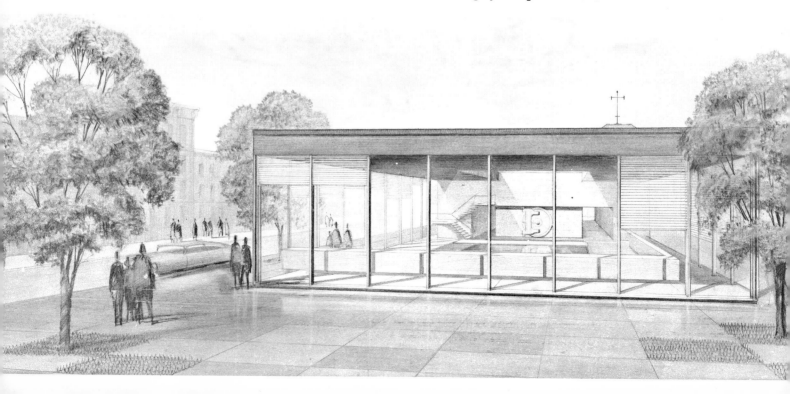

Chapter 8: MORE ON LOOKING UP, DOWN, AND STRAIGHT AHEAD

Glance again at pages 40 and 42, where the cube was viewed by "looking down" and "looking up," and note that the vertical lines do not actually remain vertical in the picture but instead appear to converge downwards and upwards respectively.

Many books state arbitrarily that such lines should always appear vertical. Although contrary to the "truth" of seeing, this rule is laid down in order to simplify matters. But such simplification is helpful only in mechanical (T-square and triangle) perspective where converging verticals means complicated drafting to establish and work with distant vanishing points, and complicated procedures to determine vertical measurements.

Therefore, when working freehand (without drafting considerations) let the visual truth dictate. If you have difficulty accepting this "truth," the following will help.

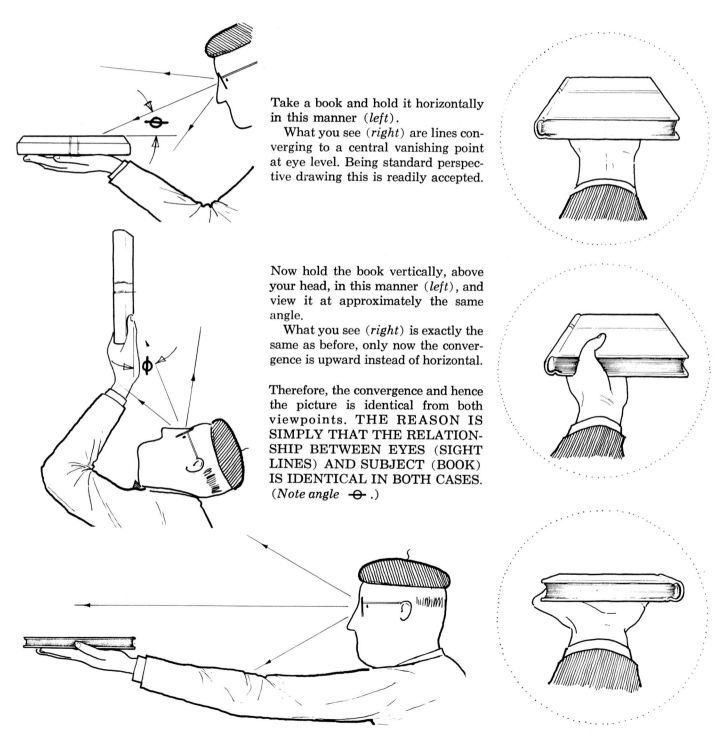

Take a book and hold it horizontally in this manner (*left*).

What you see (*right*) are lines converging to a central vanishing point at eye level. Being standard perspective drawing this is readily accepted.

Now hold the book vertically, above your head, in this manner (*left*), and view it at approximately the same angle.

What you see (*right*) is exactly the same as before, only now the convergence is upward instead of horizontal.

Therefore, the convergence and hence the picture is identical from both viewpoints. THE REASON IS SIMPLY THAT THE RELATIONSHIP BETWEEN EYES (SIGHT LINES) AND SUBJECT (BOOK) IS IDENTICAL IN BOTH CASES. (*Note angle* ⊖ .)

Try this again, from both viewpoints, with the book held almost on a level with the central visual ray. The principle is now more dramatically demonstrated because convergence and foreshortening are almost at a maximum.

But again why is upward and downward convergence so rarely used? The reason is that we usually see things by looking more or less horizontally. Not only is this attitude more natural to the anatomical structure of our neck and head, but so much of what we see exists at or near eye level.

Therefore, most of the time our central visual ray is horizontal, and consequently our imaginary picture plane is vertical (*i.e.,* at right angles to the ground). And under these conditions, vertical elements continue to appear vertical.

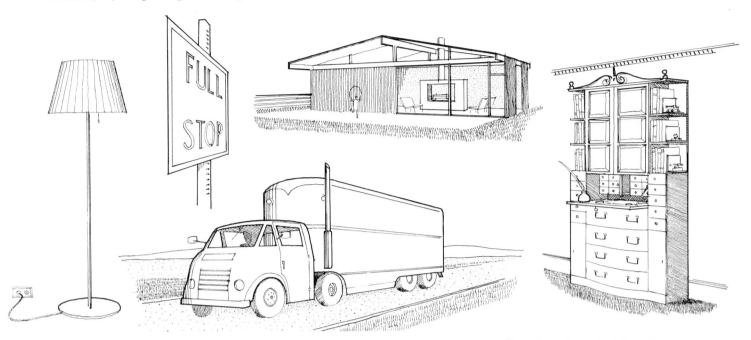

Just a few of the infinite number of things typically seen at eye level. (Note true direction of vertical lines.)

When then would upward or downward convergence be appropriate? For one thing, it could be used when drama or interest was desired. But it probably makes most sense when related to the nature of the subject matter. IN OTHER WORDS, THINGS USUALLY SEEN FROM BELOW OR FROM ABOVE SHOULD BE DRAWN WITH CONVERGING VERTICALS.

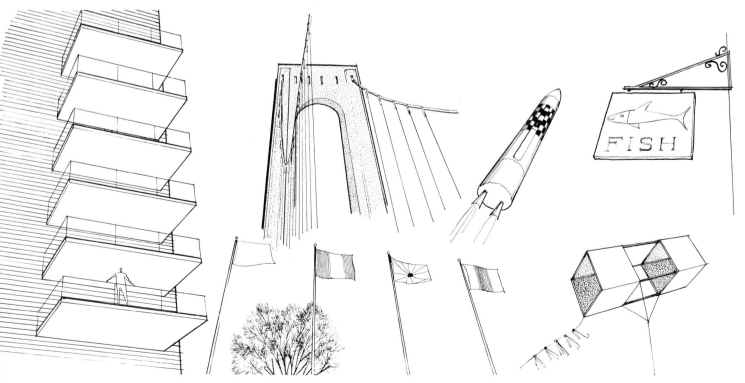

Examples of things typically seen by looking up, *i.e.,* objects usually above eye level. (Note upward convergence of vertical lines.)

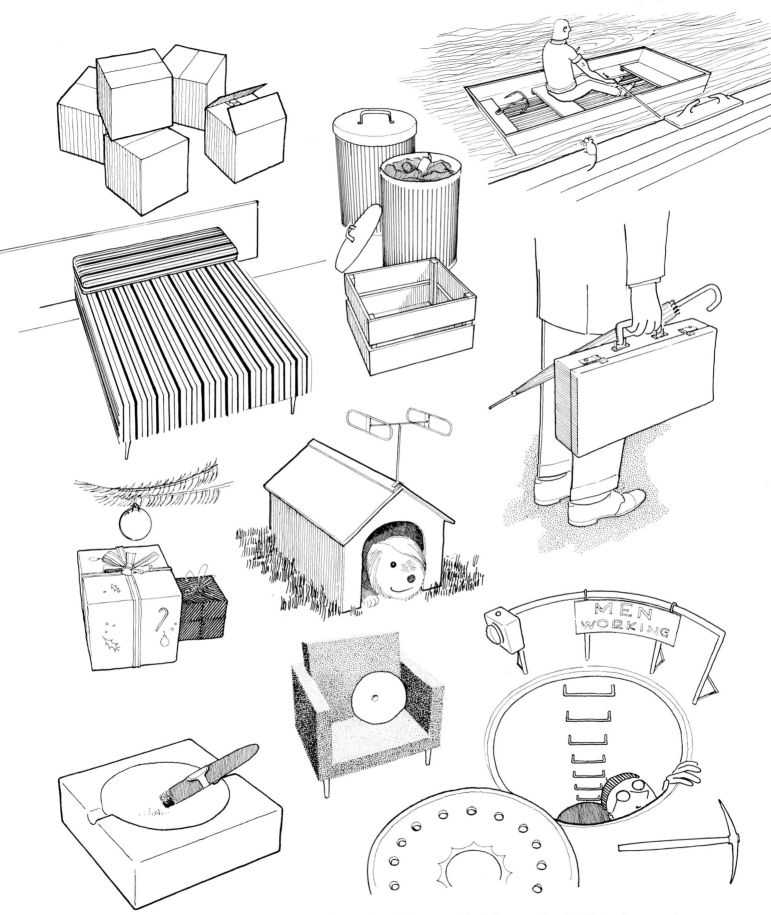

Examples of things typically seen by looking down, *i.e.,* objects usually below eye level. (Note downward convergence of vertical lines.)

So when we look up or down at an individual element, such as a single cube, each viewing angle results in a different convergence of the vertical lines. At right are the resulting pictures for each viewing angle shown at left.

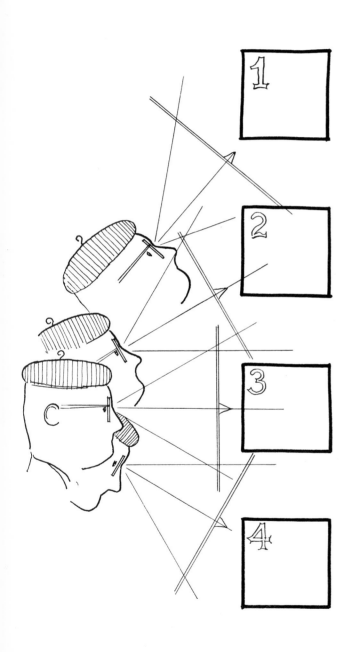

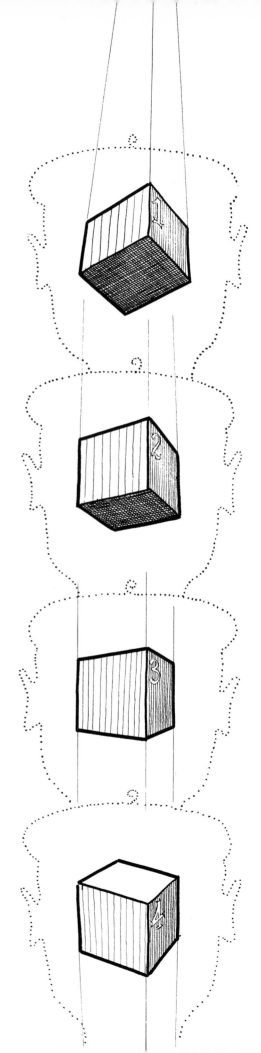

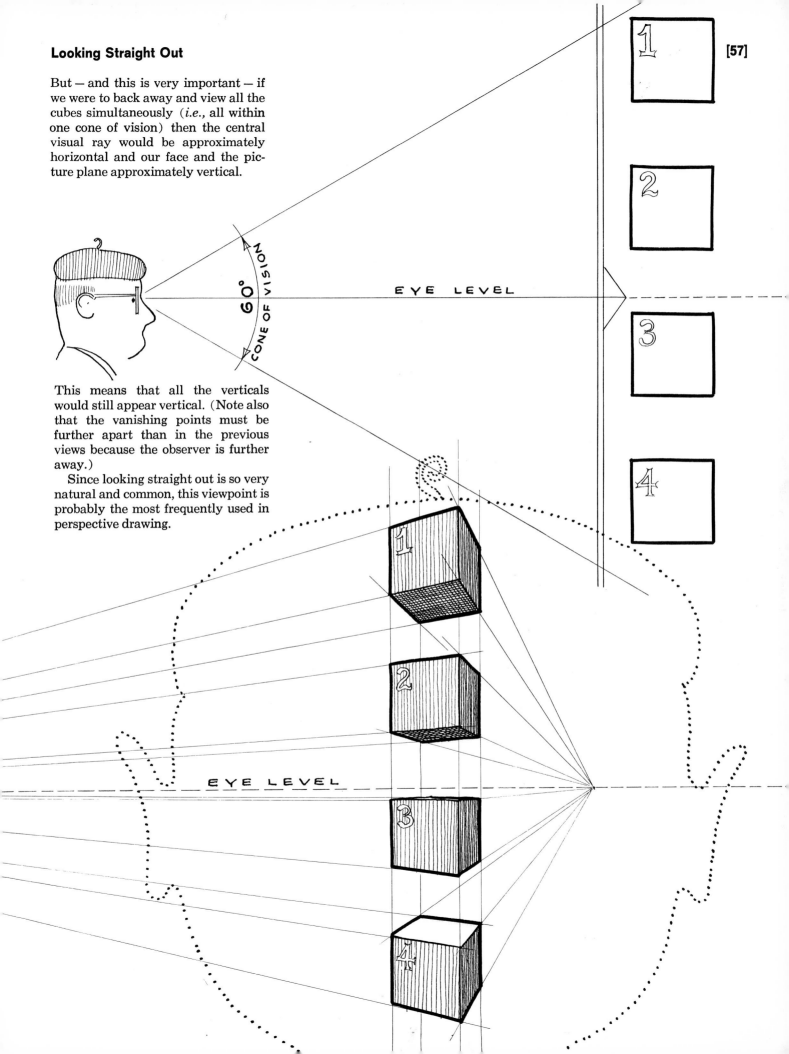

Looking Straight Out

But — and this is very important — if we were to back away and view all the cubes simultaneously (*i.e.,* all within one cone of vision) then the central visual ray would be approximately horizontal and our face and the picture plane approximately vertical.

60°

CONE OF VISION

EYE LEVEL

This means that all the verticals would still appear vertical. (Note also that the vanishing points must be further apart than in the previous views because the observer is further away.)

Since looking straight out is so very natural and common, this viewpoint is probably the most frequently used in perspective drawing.

EYE LEVEL

Chap. 9: PERSPECTIVE DISTORTION...

Is Related To Spacing Of Vanishing Points And Cone Of Vision

If we were now to add more cubes above and below using the same vanishing points as before, these new cubes would appear distorted. Their front corners (*as noted*) would be less than right angles. A cube would never appear this way.

The reason for this excessive convergence is simply that these new cubes are outside of the observer's cone of clear vision.

In real life, if the observer stepped back he would see more cubes clearly (*i.e.,* his cone of clear vision would simply include more of them) and the distortion would disappear. (*See diagram at right.*)

In a perspective drawing this distortion is eliminated simply by placing the vanishing points further apart.

The diagram at right shows that the observer "points" to increasingly distant vanishing points as he steps back.

THEREFORE: PLACING VANISHING POINTS FURTHER APART ELIMINATES DISTORTION AT EDGES OF DRAWING. IT MEANS OBSERVER HAS STEPPED BACK AND SEES MORE WITH HIS FIXED CONE OF VISION.

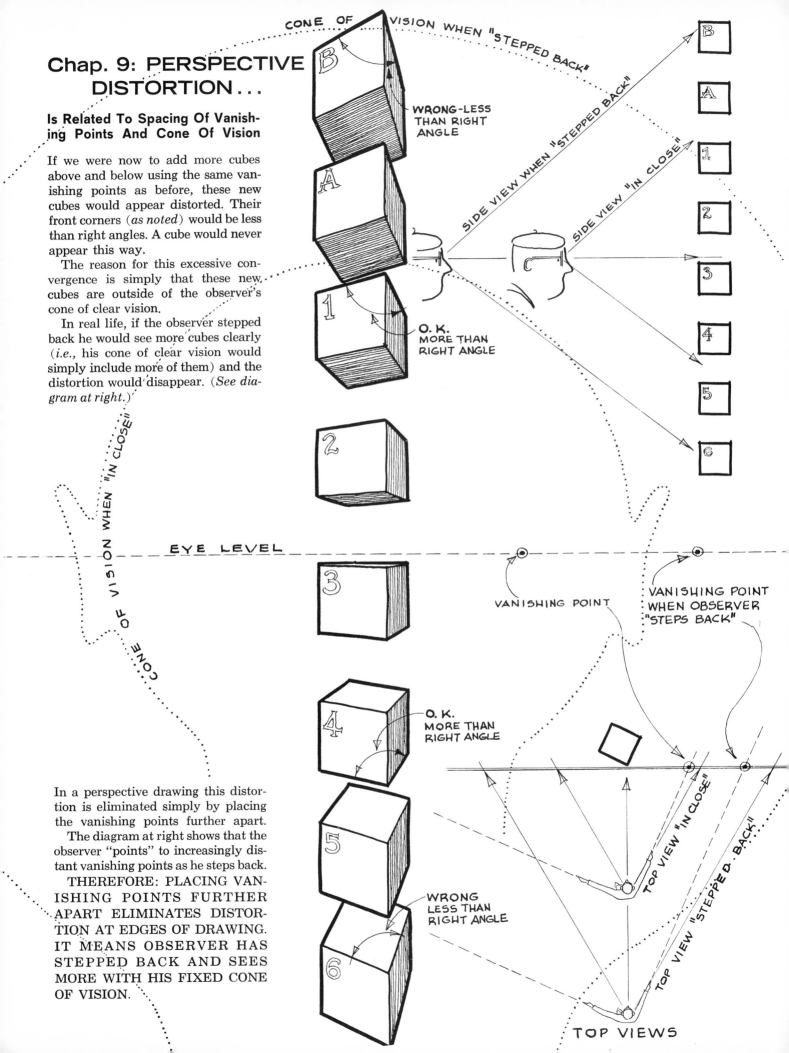

CONE OF VISION WHEN "STEPPED BACK"

WRONG-LESS THAN RIGHT ANGLE

O. K. MORE THAN RIGHT ANGLE

CONE OF VISION WHEN "IN CLOSE"

EYE LEVEL

O. K. MORE THAN RIGHT ANGLE

WRONG LESS THAN RIGHT ANGLE

SIDE VIEW WHEN "STEPPED BACK"

SIDE VIEW "IN CLOSE"

VANISHING POINT

VANISHING POINT WHEN OBSERVER "STEPS BACK"

TOP VIEW "IN CLOSE"

TOP VIEW "STEPPED BACK"

TOP VIEWS

PICTURE "IN CLOSE"

VANISHING POINT "IN CLOSE"

Now let's look at this problem with elements that are placed horizontally. We shall see that the principles and solutions are the same as before.

CONE OF VISION "IN CLOSE"

TOP VIEWS

CONE OF VISION "STEPPED BACK"

When the observer stands close to the subject, the vanishing points are relatively close together (*see top view*) and the cone of vision includes only a few cubes at the center. Cubes outside the cone of vision are excessively distorted and therefore unrealistic (*see picture above*).

But when the observer steps back, the cone of vision includes more of the subject, the vanishing points spread apart, and the distortion is eliminated (*see picture below*).

THEREFORE: If too much distortion appears in one of your drawings, either spread the vanishing points apart (which means you have "stepped back" from the subject) OR show only the undistorted center area (which means you're respecting a realistic cone of vision).

VANISHING POINT OBSERVER "STEPPED BACK"

PICTURE WHEN OBSERVER "STEPS BACK"

Distortion due to excessively close vanishing points is a common error because close vanishing points in general are easier to handle than distant ones. So don't let laziness trap you.

But also avoid the opposite extreme. Placing vanishing points too far apart is also wrong because it results in minimal convergence and hence a sense of flatness.

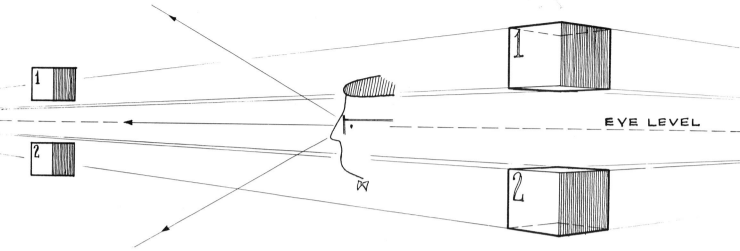

Such is the case in the drawing above (*right*). The flatness is the result either of viewing the subject from too great a distance, or of limiting the drawing to objects very near the center of the cone of vision (*see side view*). How is it corrected? Since other objects or foreground or background features (clouds, trees, room details, etc.) would normally be visible all around the subject, these, if drawn, would give the picture a realistic three-dimensional effect. (The other solution is to "move closer" to the subject — *i.e.*, use closer vanishing points and stronger convergence.)

IN GENERAL: Convergence is minimal at the center of a picture and increases as you approach the circumference of the cone of vision. Beyond this range unrealistic and unacceptable distortion begins to occur. And naturally the further you go, the worse things get (*above*).

Chapter 10: DETERMINING HEIGHTS AND WIDTHS

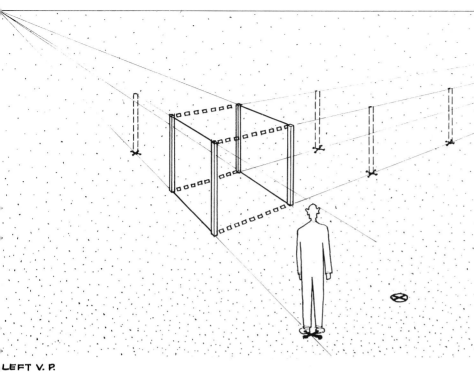

Height Lines

Assuming this is a 6 x 6 x 6-ft. cube, then the guide lines to vanishing points make all posts shown dotted also 6 ft. high. The top guide lines could be called the 6-ft. "height lines."

If we wished to draw a 6-ft. man at point **X** we would simply extend forward the appropriate bottom guide line and height line.

Suppose the figure were not on an existing guide line but, for instance, at the spot marked Ⓧ.

LEFT V. P.

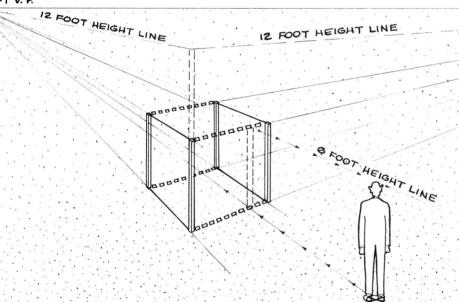

12 FOOT HEIGHT LINE

12 FOOT HEIGHT LINE

6 FOOT HEIGHT LINE

In that case, first draw the ground line to the left vanishing point. Where this intersects the face of the cube draw a vertical line (*shown dotted*). (This might be still another 6-ft.-high post in perspective.)

From the top of this imaginary post draw another vanishing line. This is the 6-ft. height line for spot Ⓧ.

Suppose you wanted to draw something 12 ft. high. Simply double the 6-ft. height and carry around the new 12-ft. height line (*lightly dotted*).

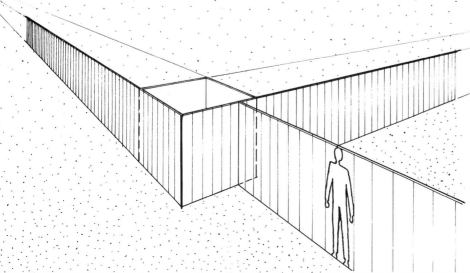

If the constructions above were imagined as a series of 6-ft.-high picket fences or walls, then the "height line" would be a real thing instead of an imaginary guide line. Here we see more clearly how these lines establish heights as they are "carried around."

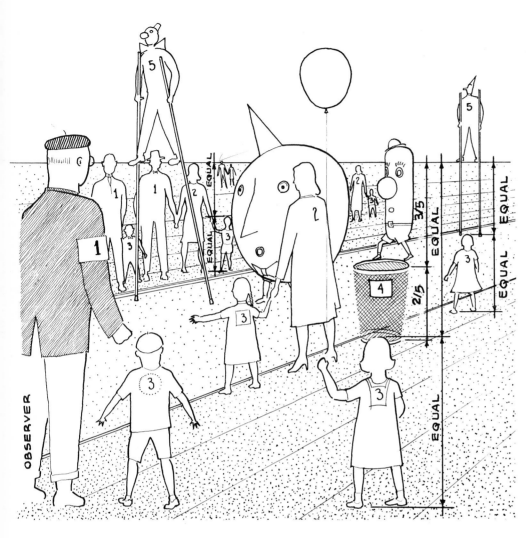

In this case, those persons (1) of about the same height as the observer and standing on the same ground plane would have their eyes at the same level as the observer's (*i.e.,* on the horizon line).

Those (2) a few inches shorter (*e.g.,* most women) would have the tops of their heads approximately at eye level.

Children — let's say 2½ ft. tall, about one-half the height of an adult — would naturally have their head-tops about half way up any standing adult figure. Therefore — no matter where they are placed (3) — the distance from the tops of their heads to eye level must equal their body height.

With eye level about 5 ft. from the floor, a 2-ft.-high wastebasket (4) would stand, wherever it were placed, at the bottom 2/5 of a vertical from ground to eye level.

What about the 5-ft. men on 5-ft.-high stilts? The footrests are at eye level, therefore these 10-unit figures (5) would always appear one-half above eye level and one-half below, regardless of where they stood.

The proportions used above for heights related to eye level are all verified in side view. It should be noted though that these proportions can be worked out "in perspective" without this aid. Reviewing the steps above will show this.

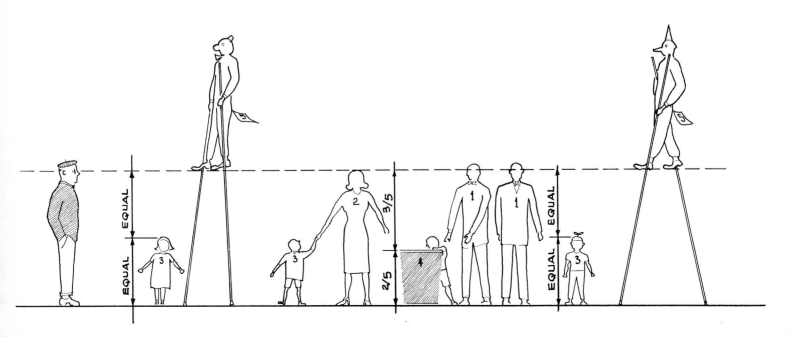

Assume the observer (1) to be 12 ft. above ground (*e.g.*, a 6-ft.-tall man on a 6-ft. ladder). This means all figures standing on the ground would appear below eye level.

The top of anything 12 ft. high, such as a wall, would therefore be level with eye level (horizon line) and would appear as shown in the drawing below.

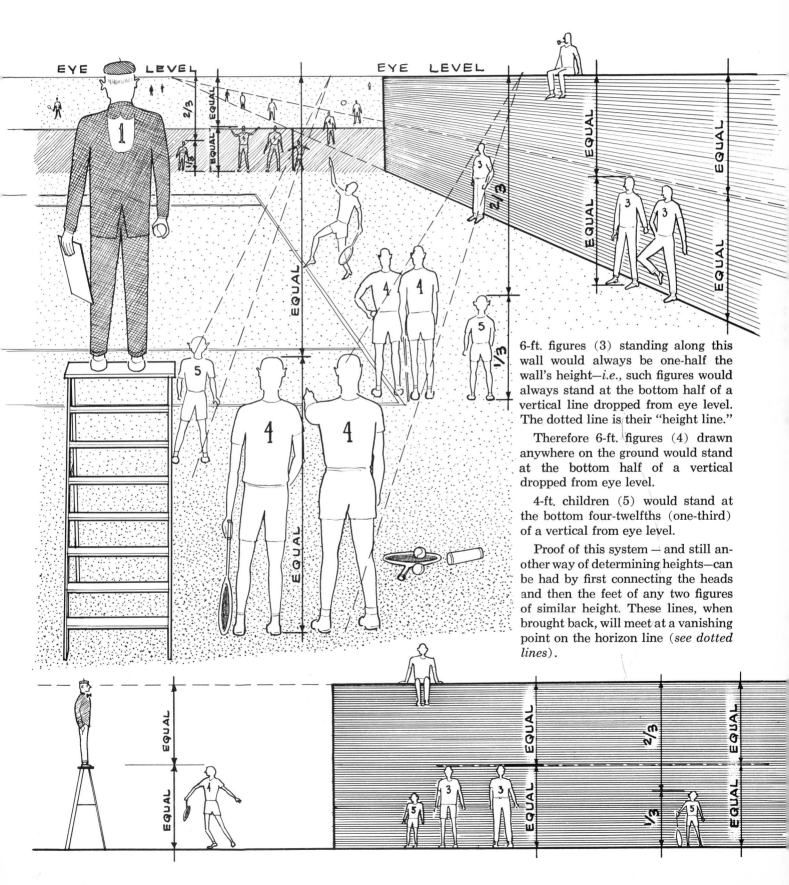

6-ft. figures (3) standing along this wall would always be one-half the wall's height—*i.e.*, such figures would always stand at the bottom half of a vertical line dropped from eye level. The dotted line is their "height line."

Therefore 6-ft. figures (4) drawn anywhere on the ground would stand at the bottom half of a vertical dropped from eye level.

4-ft. children (5) would stand at the bottom four-twelfths (one-third) of a vertical from eye level.

Proof of this system — and still another way of determining heights—can be had by first connecting the heads and then the feet of any two figures of similar height. These lines, when brought back, will meet at a vanishing point on the horizon line (*see dotted lines*).

3: Heights When Observer Is Sitting

Here the observer's eye level is about 4 ft. above the ground. In such a case, all others who are sitting (1) would also have their eyes at eye level.

Standing figures (2) would always have their heads above eye level. If they were 6 ft. tall then their lower four-sixths (two-thirds) would always be below eye level, and their upper two-sixths (one-third) always above. (*I.e.*, their rib cages would always be at eye level.)

A boy (3) exactly 4 ft. high would always have his head at eye level.

Again, if the heads and feet of any two figures of equal height were connected (*see dotted lines*) these lines would always converge to one point on the horizon line.

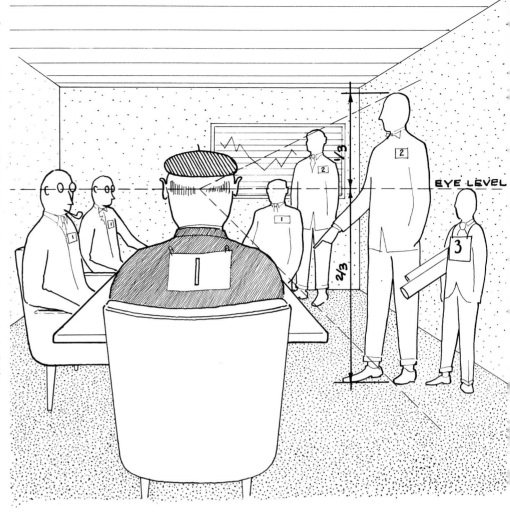

4: Heights When Observer Is Lying Down

Here the observer's eye level is about 1 ft. above the ground. Therefore objects smaller than 1 ft. would appear below eye level (*e.g.*, most beach balls).

All taller objects would have their 1-ft. level at eye level — *e.g.*, the 6-ft.-tall figures (2) would always appear one-sixth below and five-sixths above eye level.

The 5-ft.-high girl (3) would appear one-fifth below and four-fifths above eye level regardless of location.

The 2-ft.-high dog (4) would always appear one-half above and one-half below eye level.

And the top of the 1-ft.-high sand castle (5) would appear at eye level.

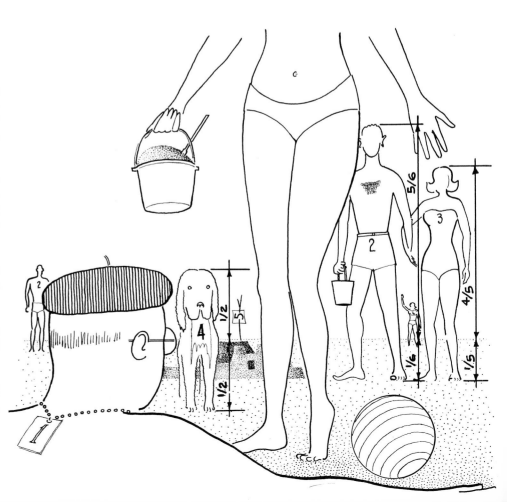

From the roof of a 30-story building all taller buildings will appear above the horizon line while those lower than 30 stories will appear below. (This assumes all buildings have similar floor heights.)

Therefore, the eye level-horizon line will cut across the 30-story level of all buildings that have one.

Naturally the 60-story Pan Am Building in the foreground appears taller than the 102-story Empire State Building because it is closer to the observer. But in both cases their 30-story levels are on the same horizontal plane as the observer's eye level.

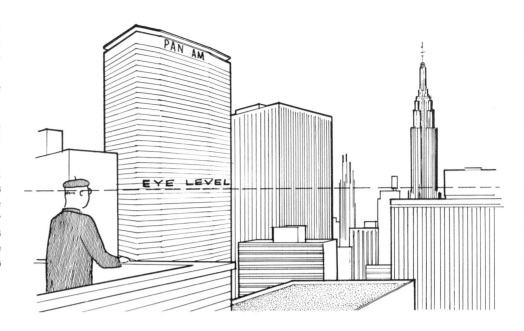

In sketching a room interior, many heights can be found by relating them to wall heights.

If a room is 8 ft. high then somewhere along the rear wall (1) or along one of the side walls (2) tick off 8 equal divisions. A 7-ft.-high door next to (1) or (2) is easily drawn.

Similarly, a door knob 3 ft. above the floor is located by the 3-ft. height line (3).

Suppose we wanted to draw a 6-ft. figure in the foreground. The dotted line (4) would provide the height.

Find the vanishing point of the receding horizontals and note that the eye level of the drawing is at the 4-ft. level. Therefore all 6-ft. figures would appear four-sixths below and two-sixths above eye level, no matter where they stood.

Drawing a 3-ft.-high chair at (5) requires carrying the door knob height across to this point. A 3-ft.-high boy (6) could be drawn by "carrying" this height line "around" the vertical at (7). (The guide lines shown use the center vanishing point, but any vanishing point along eye level could be used.) Notice how the boy's height can always be verified by the 3-ft. height line from the left.

The 1-ft.-round lamp hanging over the chair from a 1 ft. chain is drawn by using the guide lines shown as arrows.

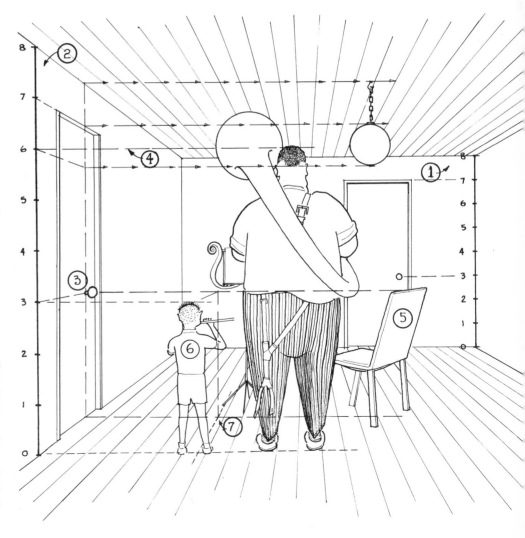

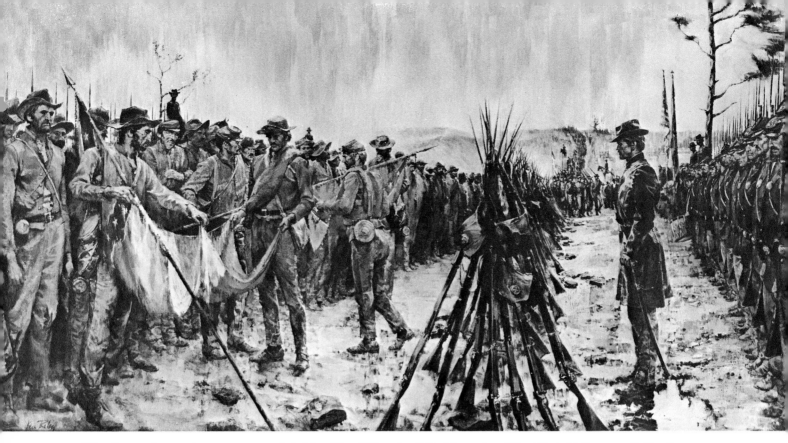

The Surrender at Appomattox, painted by Ken Riley for Life Magazine. West Point Museum Collections.

The ground is level, so the eye level-horizon line "cuts" across the same level — chest height — of all the figures.

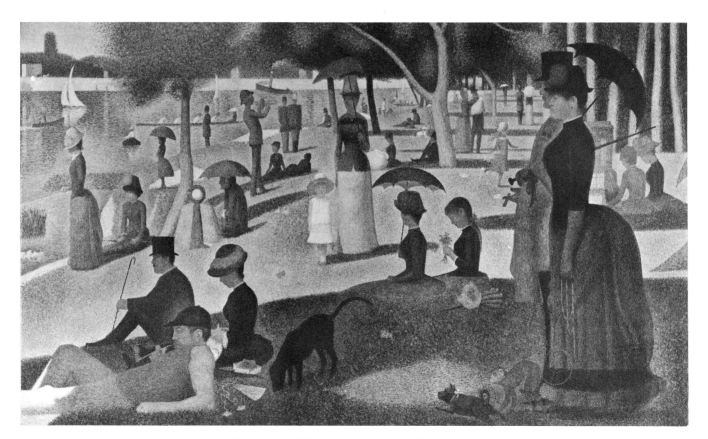

La Grande Jatte, by Georges Seurat. Courtesy of The Art Institute of Chicago.

The ground slopes toward the water. The adults standing on the higher ground have their head-tops approximately at eye level (horizon line). The adults standing along the shoreline have their head-tops generally midway between the ground and the horizon line. Note that this changing relationship of head height to horizon line almost exclusively "explains" that the land is sloping.

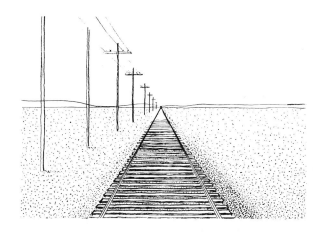 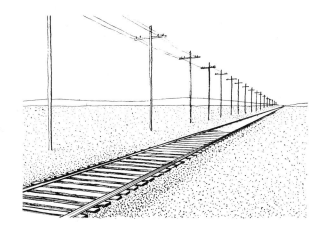

In both pictures we know that the cross-ties are really equal-sized elements. Yet diminution makes them appear successively smaller. The rails converging to a vanishing point act as guide lines for the widths of these cross-ties.

The diminution of other "flat" objects, such as boats, cars, people lying on a beach, etc., can be determined by the convergence of similar "width" guide lines.

FOR EXAMPLE:

Sketch the first object (1) in a file.

Converging guide lines to eye level will define "widths" of equally long objects in the same file (2).

Objects outside of original guide lines (3) can be drawn by transferring guide line widths to left or right (*e.g.*, dim. x = dim. x or dim. y = dim. y).

Suppose (say by means of an hydraulic jack) one of the objects (4) were at a higher or lower level. Its width is easily found by erecting verticals from the appropriate points on the guide lines to the new level. (Naturally the same eye level and vanishing point as before would be used when drawing the object.)

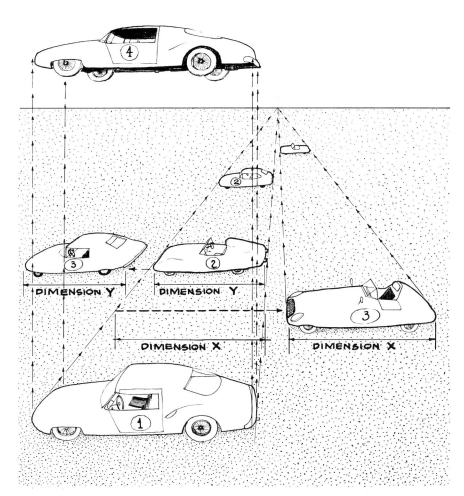

To sum up: The widths of equal-sized objects which diminish in perspective can be found by means of width guide lines that converge to a point on the horizon line.

Similarly-sized objects to the left or right can be drawn simply by translating to left or right the width of the guide lines at the point desired.

Similarly-sized elements above or below are drawn with the aid of vertical guide lines constructed at the appropriate points along the width guide lines.

Chapter 11: DETERMINING DEPTHS

Finding Center Points By Diagonals

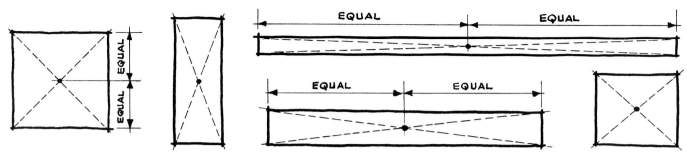

The following concept is the basis for most of the aids employed in finding perspective depths:

The diagonals of any square or rectangle (*see above*) will always intersect at the exact center of the figure — in other words, at a point equidistant from top and bottom and from left and right edges.

Thus, on this ping pong table seen directly from above, the two diagonals will naturally intersect at the net which is equidistant from the ends.

Now, when the table is drawn in perspective, where should the net be placed? If equidistant from the ends, the result is wrong (*below*).

But if located at the intersection of the diagonals the result remains true. (Imagine the diagonals as actual lines ruled on the table.)

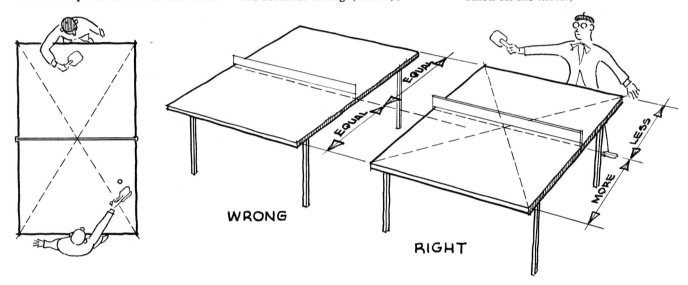

THEREFORE: TO LOCATE A MIDPOINT QUICKLY AND ACCURATELY — USE DIAGONALS.

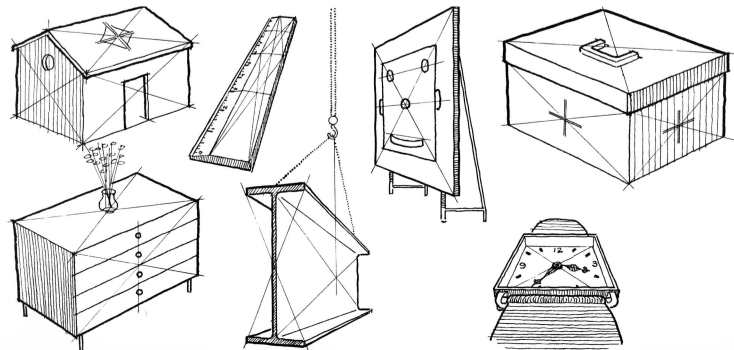

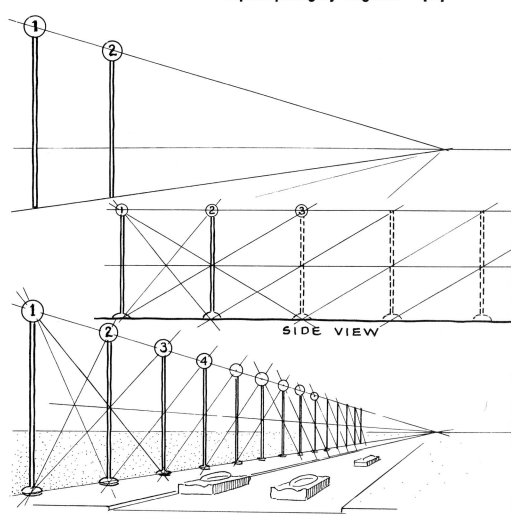

To draw equally-spaced receding elements such as lampposts, first sketch two of them between the desired top and bottom guide lines leading to their vanishing point.

Now let's develop this further in side view (*far right*).

Step A: Draw diagonals between (1) and (2) to determine midpoint. A horizontal line through this point gives us midpoint of (1), (2) and all similar verticals.

Step B: Draw diagonals from (1) through midpoint of (2), to locate (3). Since the diagonals place (2) exactly midway between (1) and (3), the location of (3) must be correct.

Step C: Subsequent equidistant verticals are located by similar diagonals. (Note: It isn't necessary to draw both diagonals. One of them, used with the center line, gives the same result.)

The application of these steps in perspective will assure equally-spaced elements drawn with proper convergence and foreshortening.

SIDE VIEW

BELOW ARE SEVERAL EXAMPLES OF THIS METHOD. STUDY THE VARIOUS APPLICATIONS.

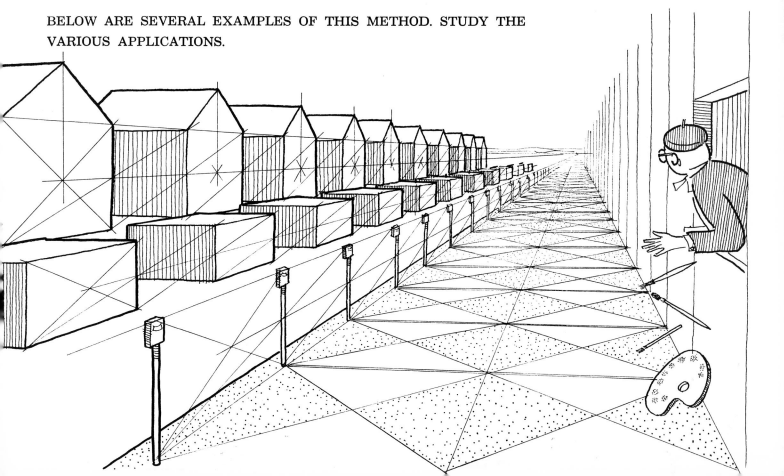

[70] Subdividing A Surface By Diagonals

Suppose we wanted to divide face A of this object into two equal spaces, face B into four equal spaces, and the top into eight equal spaces.

BELOW is the solution when each face is viewed head-on.

AT RIGHT is the same solution in perspective.

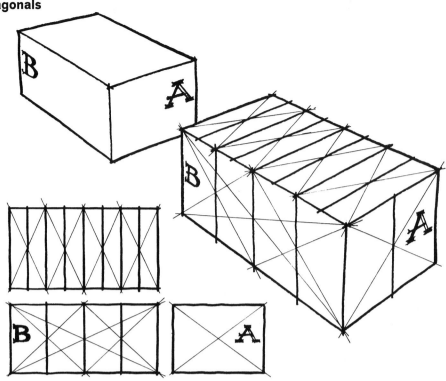

Naturally, this method works only when the number of spaces is 2, 4, 8, 16, 32, 64, etc. Suppose we wished to divide a face into 7 or 10 spaces. Then the following method should be used, for it works for any number of equal spaces.

Dividing A Surface Into Equal Spaces By Using A Measuring Line And A Special Vanishing Point

(Please follow the numbered steps.)

STEP 1: From lowest corner of face to be divided draw horizontal line and tick off the number of equal spaces desired (7 in this case).

STEP 3: Connect other six points to special vanishing point. These guide lines will intersect base line of object, creating seven equal spaces in perspective.

Note: The equal spaces ticked off in step 1 could be at any scale. Those shown are each ⅜″ spaces, but could be ¼″, ½″, ⅝″, etc. Naturally every spacing will shift the special vanishing point, but the resulting perspective spacing will always be the same.

Why this is so is explained in this top view. Let's divide the same face in two, using different spacings. From the lowest corner tick off two units of ½″ each, two of 1″ and two of 2″. Now, connect each second tick to the far corner (*3 lines shown dotted*). Then, from the first ticks, draw lines parallel to these. Note that the second lines all intersect at the midpoint of the face. Therefore any of these spacings would work even though each resulting set of parallel-horizontal lines would have it own (special) vanishing point (*see across page*).

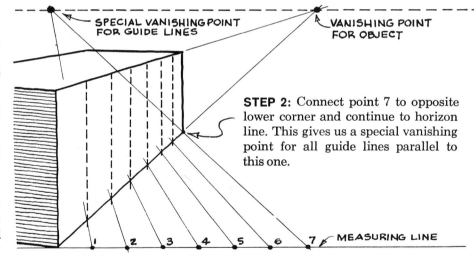

STEP 2: Connect point 7 to opposite lower corner and continue to horizon line. This gives us a special vanishing point for all guide lines parallel to this one.

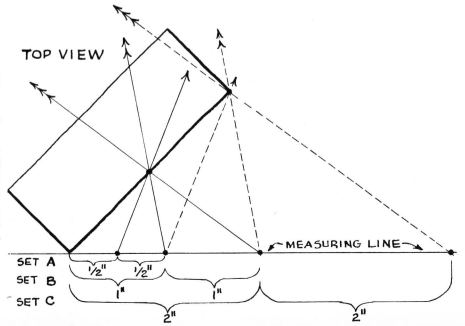

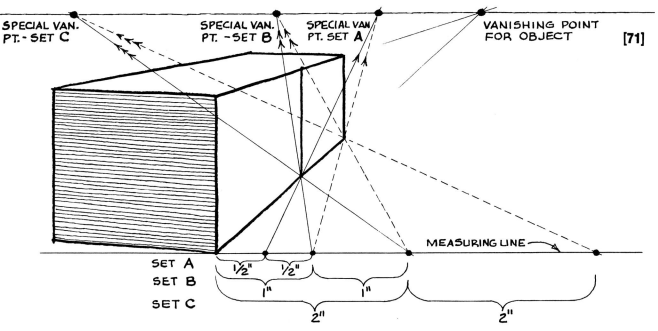

SPECIAL VAN.
PT. - SET C

SPECIAL VAN.
PT. - SET B

SPECIAL VAN
PT. SET A

VANISHING POINT
FOR OBJECT

[71]

MEASURING LINE

SET A
SET B
SET C

½" ½" 1" 1" 2" 2"

This is the previous top view diagram seen in perspective. So remember: THE SPACING USED ALONG THE MEASURING LINE CAN BE AT ANY SCALE.

Dividing A Surface Into UNEQUAL Spaces With A Measuring Line And Special Vanishing Point

The "measuring line" method of dividing perspective surfaces may also be used with unequal spaces. Suppose a 2-ft. opening is to be located on a wall, spaced as below.

1' 2' 4'

(*Follow numbered steps as before.*)

STEP 1: Tick off 1 unit, 2 units, and 4 units on measuring line. (As before, the units can be at any scale. The principle is the same as in the case above.)

STEP 3: Bring other lines to special vanishing point. This locates opening on wall.

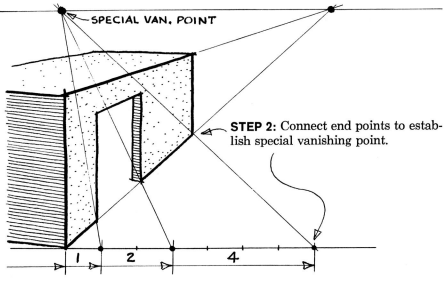

— SPECIAL VAN. POINT

STEP 2: Connect end points to establish special vanishing point.

1 2 4

Once correct spacing is found on wall, the distances could be extended forward (from left vanishing point) to create, say, a 2-ft.-wide walk or a 4-ft.-long bench.

Or, by carrying guide lines up the wall and over the roof, a 2-ft.-wide chimney could be drawn. But note that to fix the depth of this chimney (1 ft.), we need a new measuring line and special vanishing point, and new guide lines (*shown dotted*).

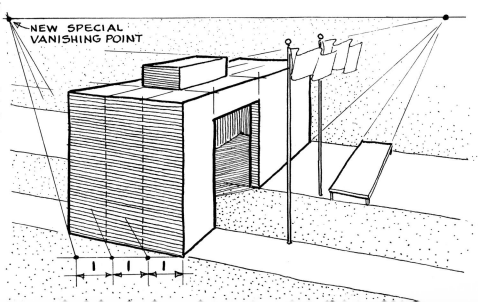

NEW SPECIAL
VANISHING POINT

1 1 1

Here, floor to ceiling screens are placed as shown in top view below. Also at the same one-third points are thin wall lines, *e.g.*, mullions.

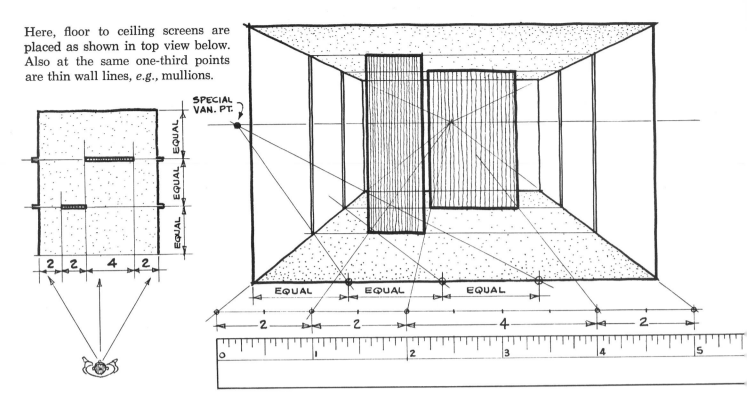

1. The *depth* locations of the mullions (and screens) are found as before (*see pp. 70, 71*) — by ticking off three equal spaces on a measuring line and drawing converging lines to a special vanishing point.

2. The *left to right* locations of the screens are then found by means of another measuring line ten units long (2+2+4+2). (Units may be at any scale. Here, each unit = ½".)

3. The location of this measuring line is determined by sliding a ruler back and forth until the desired number of units fits exactly between projections of the floor lines.

In this top view, the elements receding from observer are unequally spaced. But, as we have seen on the previous page, the same method can be used.

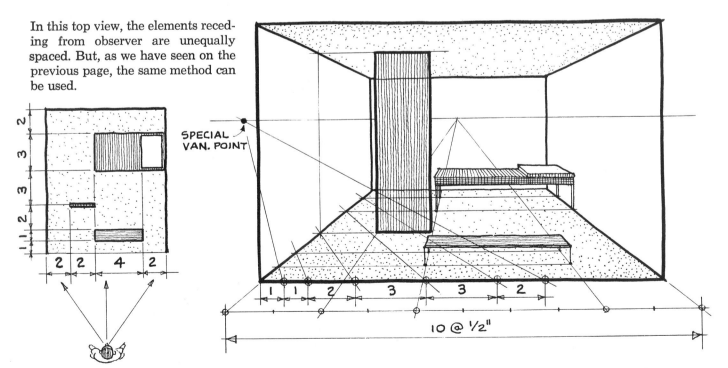

Again the depth locations are found by ticking off the appropriate spaces along the measuring line, connecting the last tick with room corner, and then all other ticks to the special vanishing point. This locates spacing along the left wall base, from which it is carried across the room. The left to right locations are the same as in the case above and are found as above.

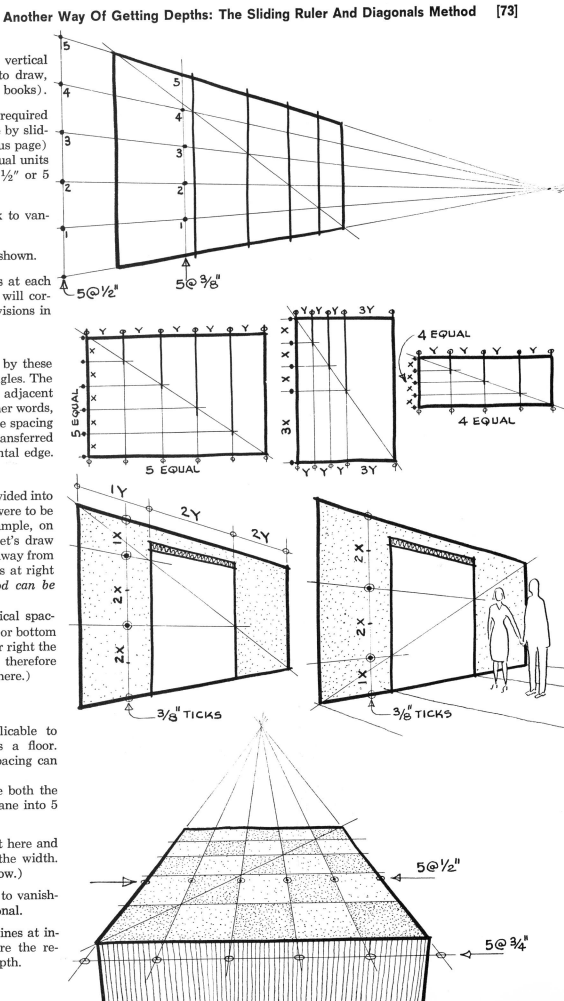

Suppose we wanted 5 equal vertical divisions in this rectangle (to draw, for instance, 5 equally-thick books).

STEP 1: Simply tick off the required spacing on some vertical line by sliding a ruler (as on the previous page) to find a position where 5 equal units fit. (Note that either 5 @ ½″ or 5 @ ⅜″ would be o.k.)

STEP 2: Converge each tick to vanishing point at right.

STEP 3: Draw diagonal as shown.

STEP 4: Draw vertical lines at each point of intersection. These will correctly demarcate 5 equal divisions in perspective.

Why this is so is explained by these front views of various rectangles. The diagonals always divide the adjacent sides proportionately. In other words, by means of the diagonal the spacing along a vertical edge is transferred proportionately to a horizontal edge.

Suppose, instead of being divided into equal spaces, the rectangle were to be divided unequally. For example, on the same 5-unit-long wall let's draw a 2-unit door located 1 unit away from the front end. The drawings at right show that *the same method can be used for unequal spacing.*

(Note: always start vertical spacing ticks from the same top or bottom edge as diagonal. *E.g.*, at far right the diagonal starts at bottom, therefore the 1-unit tick also starts there.)

This method is also applicable to horizontal planes such as a floor. Again, equal or unequal spacing can be determined.

For instance, let's divide both the depth and width of this plane into 5 equal spaces.

STEP 1: 5 spaces @ ½″ fit here and so can be used to divide the width. (Or use 5 units @ ¾″, below.)

STEP 2: Draw guide lines to vanishing point, then draw diagonal.

STEP 3: Draw horizontal lines at intersection points. These are the required 5 equal spaces in depth.

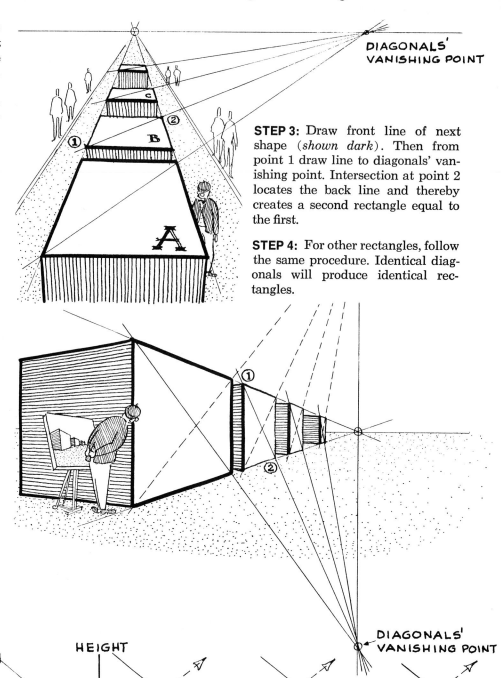

Suppose we drew one shape, such as rectangle A, and wished to repeat it (for instance, in order to draw a line of cars on a road). If the rectangles were touching, the method of diagonals shown on page 69 could be used, but since they are not, another method is needed.

STEP 1: Draw the diagonal of the first rectangle and extend it to the horizon line. This locates the vanishing point for this and all other lines parallel to it.

STEP 2: Extend the sides of rectangle A to *their* vanishing point. These are the "width guide lines" for all rectangles in line with the first.

This method will also work for vertical planes, such as a row of building facades, sides of trucks, etc.

The procedure is exactly as above and the diagram is identical. (Revolve this book 90 degrees and see.)

Note that the horizon line of the first case now becomes a vertical line. But like the horizon line, this vertical receives all lines on, or parallel to, the wall plane. The diagonals, therefore, converge to a point on this line as shown. (If the other set of diagonals (*shown dotted*) were used, their vanishing point would be above eye level but on the same vertical line.)

STEP 3: Draw front line of next shape (*shown dark*). Then from point 1 draw line to diagonals' vanishing point. Intersection at point 2 locates the back line and thereby creates a second rectangle equal to the first.

STEP 4: For other rectangles, follow the same procedure. Identical diagonals will produce identical rectangles.

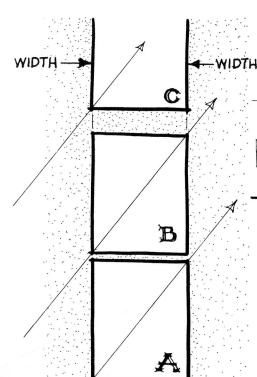

An examination of the top view of the first example (*left*) and the side view of the second (*above*) will show why this works.

Note that once the width or height lines are drawn, any set of parallel lines will strike off equally-long rectangles by becoming their diagonals. And since they are parallel these lines naturally converge to the same point in perspective (the diagonals' vanishing point).

Within a square or rectangle, a multitude of concentric patterns can be drawn in correct perspective by bringing horizontals to their vanishing point, drawing verticals, and "turning" the pattern at the diagonals.

Essentially, the diagonals allow you to "carry the pattern around," thereby maintaining symmetry. Studying the side view of the design at right will help explain how this works in perspective.

Suppose you had determined one point on a rectangle (such as one of the knobs of a radio) and wished to locate another symmetrically.

(The following procedure applies both to top view and perspective drawing.) *1st:* Draw diagonals. *2nd:* Carry around guide lines (*arrows*) as shown. Basically, this creates a concentric rectangle. *3rd:* Draw line parallel to side of rectangle (*shown dotted*) to locate the desired point.

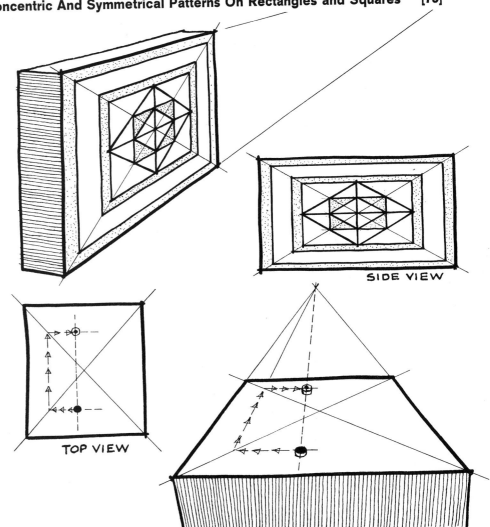

SIDE VIEW

TOP VIEW

Many symmetrical patterns can be drawn accurately and quickly by using diagonals in this manner.

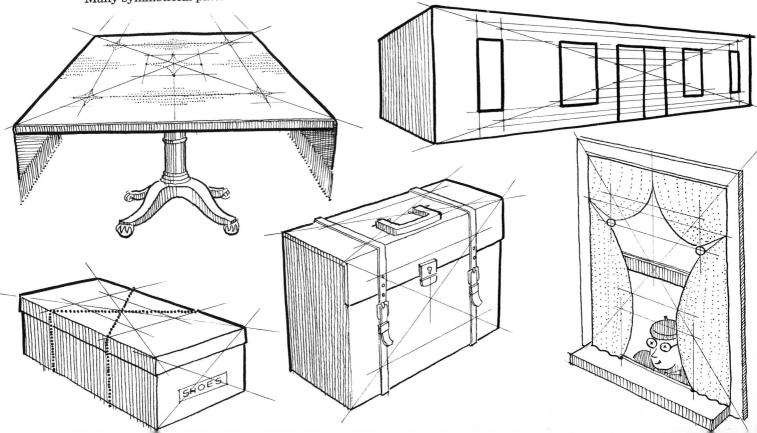

SHOES

[76] Any Design Or Pattern Can Be Reproduced In Perspective By Means Of A Grid That Locates Its Important Points

For example, in the drawing at right, grid lines (*light lines*) have been drawn through the design's key points. This grid "transfers" the spacing of the points to the edges of the surrounding rectangle, thus creating measuring lines 1 and 2.

MEASURING LINE NO. 2

MEASURING LINE NO. 1

(A)

SPECIAL VANISHING POINT NO. 1

SPECIAL VANISHING POINT NO. 2

To locate the design in perspective, we simply draw the rectangle by approximation and then lay out measuring lines 1 and 2 from point A as shown. By using the special vanishing points of these lines, we can then transfer the edge measurements to the perspective rectangle. This, in turn, allows us to draw the grid in perspective, and the grid intersections enable us to reconstruct the design.

MEASURING LINE NO. 1 MEAS. LINE NO 2.

(A)

Here again a series of key points has been located on a grid, which has then been drawn in perspective.

The spacing of the points was transferred to the perspective view by using measuring lines "A to E" and "0 to 6".

(Measuring line "0 to 6" was located simply by sliding a paper with ticked-off spacings back and forth until it fit exactly between the proper guide lines.)

A B C D E

VANISHING POINT FOR MEASURING LINE A-E

0 1 2 3 4 5 6 MEASURING LINE

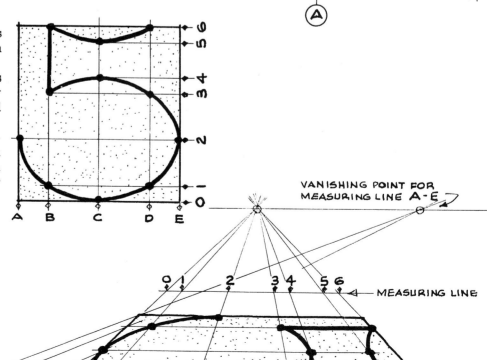

MEASURING LINE

A B C D E

Chapter 12: INCLINED PLANES – INTRODUCTION

Since the bottom of this box is horizontal, its converging lines always vanish to eye level. An observer pointing in the direction of the box (horizontally) therefore points to its "vanishing line" (*first drawing*).

So it is with the pivoting box top. An observer pointing in the same direction as this variously-inclined plane points to *its* successive vanishing lines.

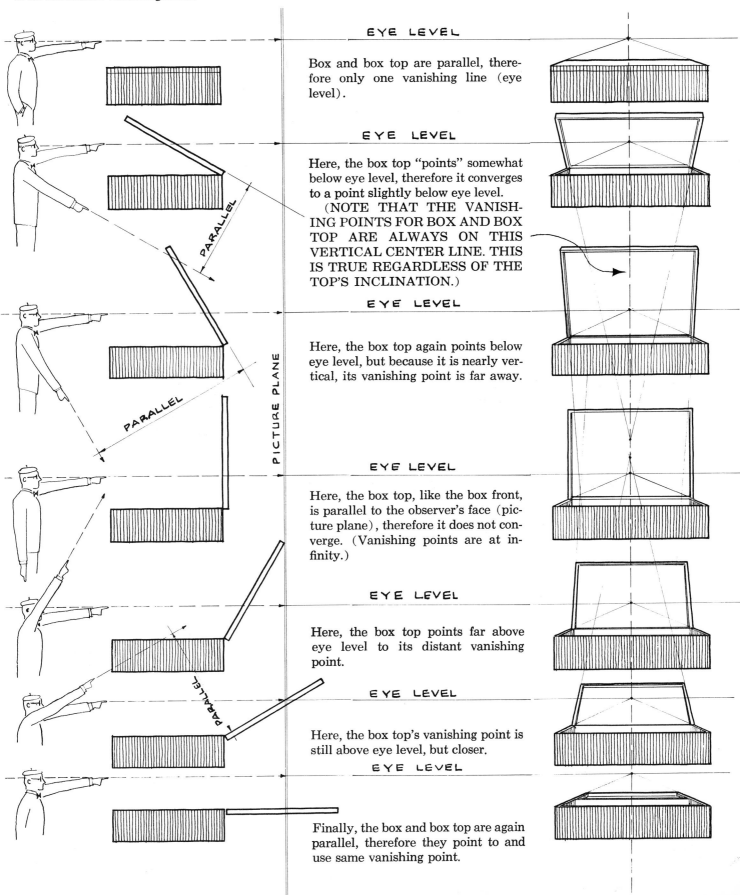

EYE LEVEL

Box and box top are parallel, therefore only one vanishing line (eye level).

EYE LEVEL

Here, the box top "points" somewhat below eye level, therefore it converges to a point slightly below eye level.

(NOTE THAT THE VANISHING POINTS FOR BOX AND BOX TOP ARE ALWAYS ON THIS VERTICAL CENTER LINE. THIS IS TRUE REGARDLESS OF THE TOP'S INCLINATION.)

EYE LEVEL

Here, the box top again points below eye level, but because it is nearly vertical, its vanishing point is far away.

EYE LEVEL

Here, the box top, like the box front, is parallel to the observer's face (picture plane), therefore it does not converge. (Vanishing points are at infinity.)

EYE LEVEL

Here, the box top points far above eye level to its distant vanishing point.

EYE LEVEL

Here, the box top's vanishing point is still above eye level, but closer.

EYE LEVEL

Finally, the box and box top are again parallel, therefore they point to and use same vanishing point.

PICTURE PLANE

PARALLEL

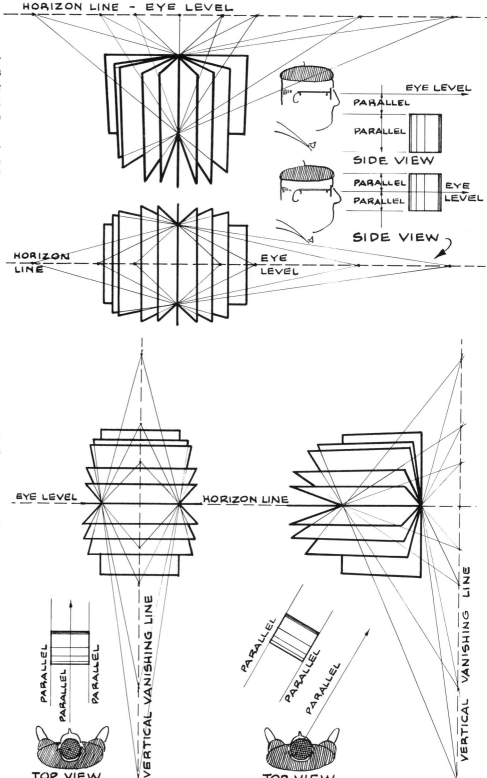

First let's review: The top and bottom edges of each page of the books at right lie on horizontal planes (*see side view*). Therefore, they must all converge to the horizon line (eye level), which we recall is always on a horizontal plane through the observer's eyes — *i.e.*, parallel to the planes in question. (*See pages 28 and 29 for further review.*)

Now suppose we held the book this way (if it were possible) so that both the "top" and "bottom" (here, left and right) edges of the pages are now bounded by vertical, rather than horizontal, parallel planes. As above, these two parallel planes, and all the lines that lie on them, will converge to one vanishing line. But in this case the vanishing line is vertical. Where is it located? As in the case above, it is situated on a plane through the observer's eyes and parallel to the planes in question (*see top views*).

In the diagram at far right, the left and right edges of the pages, and hence the plane through observer's eye, point to the right, therefore the vertical vanishing line shifts to the right.

So it is important to realize that vertical vanishing lines and the horizon line (eye level) serve the same purpose and are similar in concept. Both "contain" the vanishing points for parallel sets of lines which lie on parallel planes. The horizon line serves all sets of lines on horizontal planes while a vertical vanishing line serves all sets of lines on parallel vertical planes. Both are found in the same manner; in fact the drawings above and below are identical except for being turned 90 degrees from each other.

The diagrams at the bottom of this page and on the previous page also show that the vanishing point for parallel lines on inclined planes (*e.g.*, the edges of the book pages or the sides of the box top) is always directly above or below the vanishing point those lines would have if they were pivoted to a horizontal position.

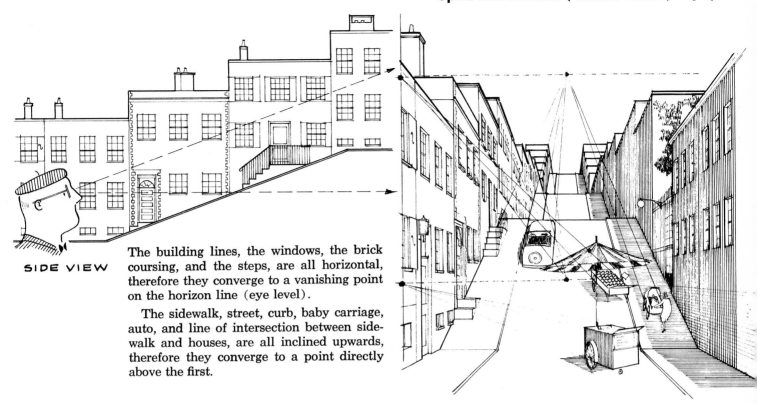

SIDE VIEW

The building lines, the windows, the brick coursing, and the steps, are all horizontal, therefore they converge to a vanishing point on the horizon line (eye level).

The sidewalk, street, curb, baby carriage, auto, and line of intersection between sidewalk and houses, are all inclined upwards, therefore they converge to a point directly above the first.

Now note the ice cream vendor's wagon and the pushcart. The wagon is on the level part of the street, so its lines naturally converge to vanishing points on the horizon line. The lines of the pushcart on the inclined plane, on the other hand, converge to points along the vanishing line of the inclined plane. But since both vehicles are turned at the exact same angle from the sidewalk, their vanishing points (left and right) lie on the same vertical vanishing lines, directly above and below one another.

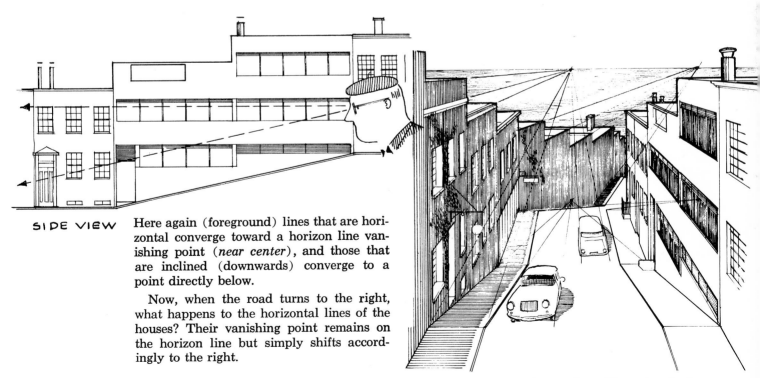

SIDE VIEW

Here again (foreground) lines that are horizontal converge toward a horizon line vanishing point (*near center*), and those that are inclined (*downwards*) converge to a point directly below.

Now, when the road turns to the right, what happens to the horizontal lines of the houses? Their vanishing point remains on the horizon line but simply shifts accordingly to the right.

And if the road also goes downhill its vanishing point is directly below this new horizon point. (Note that both downhill vanishing points are on the same horizontal vanishing line because the angle of incline is the same.)

TO REPEAT: THE VANISHING POINT FOR PARALLEL LINES ON AN INCLINED PLANE IS ALWAYS DIRECTLY ABOVE OR BELOW THE VANISHING POINT THOSE LINES WOULD HAVE IF THEY WERE PIVOTED TO A HORIZONTAL POSITION. (*See p. 77.*)

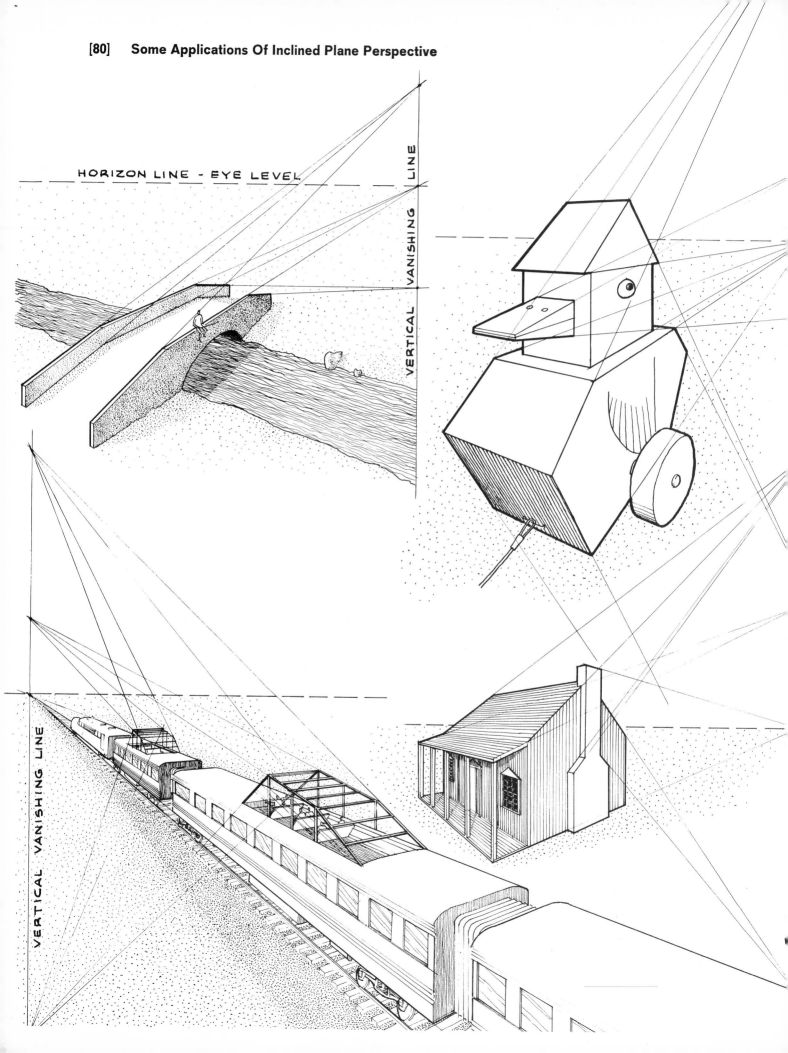

HORIZON LINE - EYE LEVEL

VERTICAL VANISHING LINE

VERTICAL VANISHING LINE

Chapter 13: CIRCLES, CYLINDERS AND CONES

Circles And Ellipses: Circles, Except When They Are Parallel To Observer's Face, Will Foreshorten And Appear As Ellipses

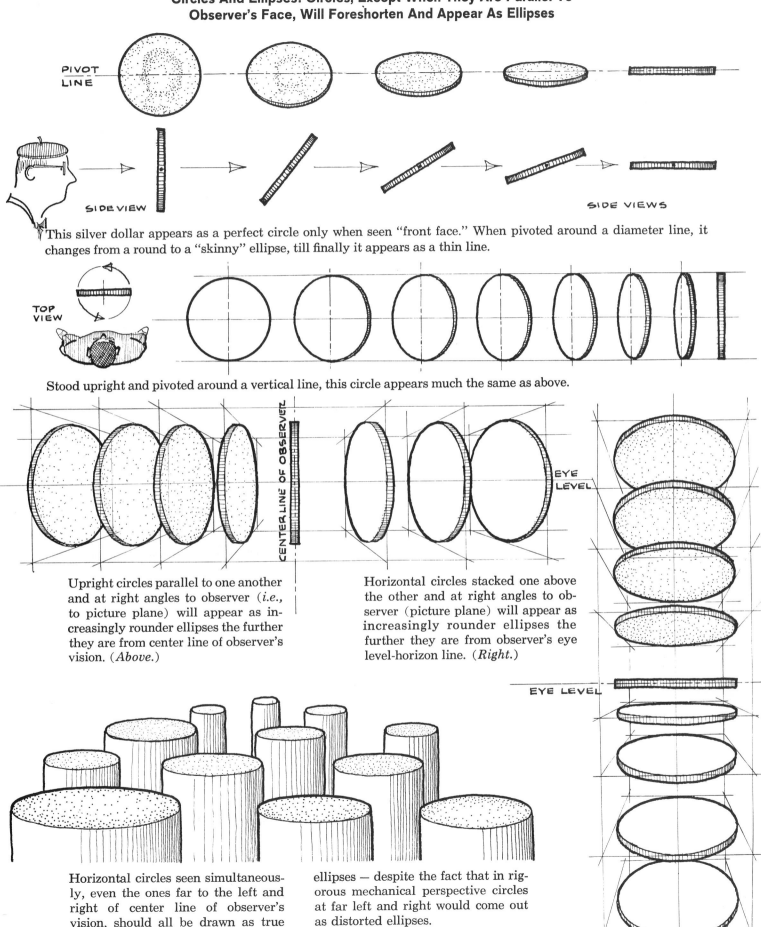

This silver dollar appears as a perfect circle only when seen "front face." When pivoted around a diameter line, it changes from a round to a "skinny" ellipse, till finally it appears as a thin line.

Stood upright and pivoted around a vertical line, this circle appears much the same as above.

Upright circles parallel to one another and at right angles to observer (*i.e.*, to picture plane) will appear as increasingly rounder ellipses the further they are from center line of observer's vision. (*Above.*)

Horizontal circles stacked one above the other and at right angles to observer (picture plane) will appear as increasingly rounder ellipses the further they are from observer's eye level-horizon line. (*Right.*)

Horizontal circles seen simultaneously, even the ones far to the left and right of center line of observer's vision, should all be drawn as true ellipses — despite the fact that in rigorous mechanical perspective circles at far left and right would come out as distorted ellipses.

The two-dimensional circles on the previous page could represent coins, phonograph records, pancakes, lenses, etc. (*right*). But circles are also key parts of three-dimensional objects such as cylinders and cones, and as such have wide application in representational drawing. Cylinders are the bases of an endless number of things such as cigarettes, oil tanks, threadspools, chimneys, etc. Cones are the bases of ice cream cones, hour glasses, martini glasses, funnels, etc. Therefore, the importance of learning to draw circles in perspective — *i.e.*, ellipses—can hardly be overestimated.

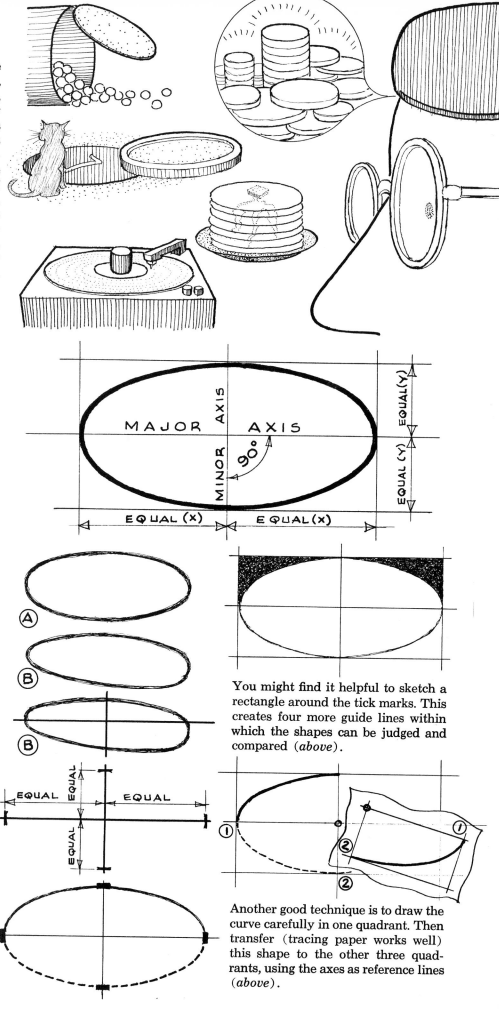

What Is An Ellipse And How Can We Learn To Draw It?

An ellipse is an oval figure with two unequal axes (major and minor) which are *always* at right angles to one another. These axes connect, respectively, the figure's longest and shortest dimensions, and about each of them the curve of the ellipse is absolutely symmetrical. This means four identical quadrants, with each axis dividing the other exactly in half ($x=x, y=y$).

One should learn to draw an ellipse freehand with a loose, free-swinging stroke. Ellipses *A* and *B* are attempts at this. Anyone familiar with ellipses can visualize the major and minor axes and see that *A* is good while *B* lacks the necessary symmetry. (If we draw *B's* two axes, we can see the errors much more clearly. Notice how each quadrant differs.)

So a good way to begin learning to draw (and to visualize) ellipses is to start by sketching these axes. Tick off equal dimensions on either side of the center to locate extremities.

Then try drawing four equal quadrants. *Note:* the ends are always rounded, never pointed.

You might find it helpful to sketch a rectangle around the tick marks. This creates four more guide lines within which the shapes can be judged and compared (*above*).

Another good technique is to draw the curve carefully in one quadrant. Then transfer (tracing paper works well) this shape to the other three quadrants, using the axes as reference lines (*above*).

This astonishing fact is often a cause of great difficulty (even in books on the subject). What is the relationship between the circle's center and the ellipse's axes?

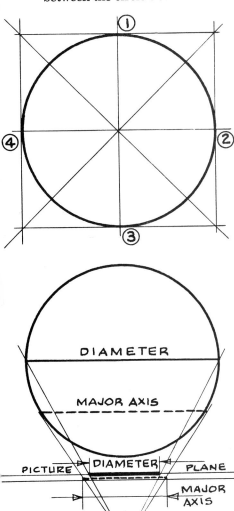

A true circle can always be surrounded by a true square. The center of the square (found by drawing two diagonals) is also the center of the circle (*left*).

The circle in perspective (*right*) can also be surrounded by a foreshortened square. Drawing the diagonals will therefore give the center of both square and circle. We know from page 68 that this point is not midway between top and bottom lines. So the circle's diameter drawn through this center point is also not midway between top and bottom.

Yet we know (*right*) that the major axis of an ellipse must be midway between top and bottom lines.

So, combining the two drawings (*right*) we see that the circle's diameter falls slightly behind the ellipse's major axis. (Note, too, that the minor axis is always identical with the most foreshortened diameter of the circle.)

The top view (*left*) explains this seeming paradox. The widest part of the circle (seen or projected onto the picture plane) is not a diameter but simply a chord (*shown dotted*). It is this chord which becomes the major axis of the ellipse, while the circle's true diameter, lying beyond, appears and "projects" smaller.

This is true regardless of the angle or position of the ellipse.

So don't make the mistake of drawing a foreshortened square and using its center to locate the major axis of an ellipse. The resulting figure would look something like this (*right*).

Also, if you wish to draw half a circle (or cylinder) you cannot draw an ellipse and consider either side of the major axis to be half of a foreshortened circle. *E.g.*, the figure at left is not half but less.

The two at right, however, are each proper halves, because the circle's diameter is used as the dividing line.

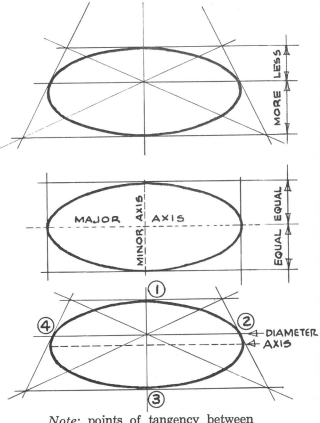

Note: points of tangency between ellipse and square (1, 2, 3, 4) are exactly at diameter lines, just as in the true top view (*upper left*).

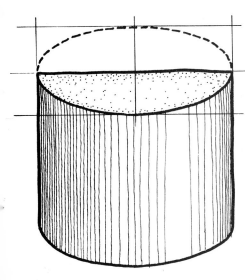

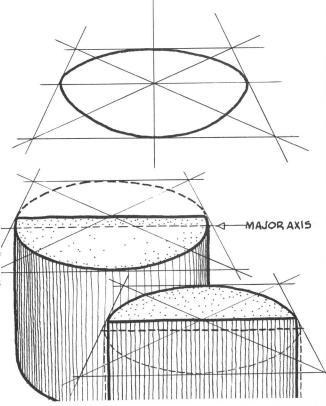

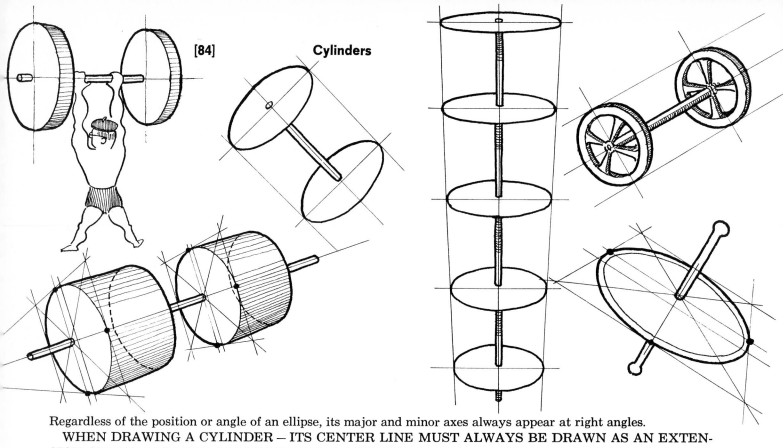

[84] **Cylinders**

Regardless of the position or angle of an ellipse, its major and minor axes always appear at right angles.

WHEN DRAWING A CYLINDER — ITS CENTER LINE MUST ALWAYS BE DRAWN AS AN EXTENSION OF THE RELATED ELLIPSE'S MINOR AXIS. Therefore, this center line (the axle of wheels, the crossbar of bar bells, the shaft of a gyroscope, etc.) *always* appears at right angles to the major axis of the ellipse associated with it.

But note that this center line connects to the ellipse at the center point of the circle and not to the center of the ellipse. (Otherwise the shaft would be eccentric — literally "off center." *See previous page.*)

By redrawing two of the objects above, we can see here that foreshortened squares in any direction can be constructed as guides around a circle. But in every case THE OPPOSITE POINTS OF TANGENCY (*dots*) will TERMINATE DIAMETER LINES THROUGH THE CIRCLE'S CENTER. (In reality these lines are at right angles.)

The ellipse's major axis (*dotted*) has nothing to do with this — it is merely a guide line for drawing the ellipse. (Note again that the ellipse's center is closer to the observer than the circle's center.)

Below are some applications of these principles.

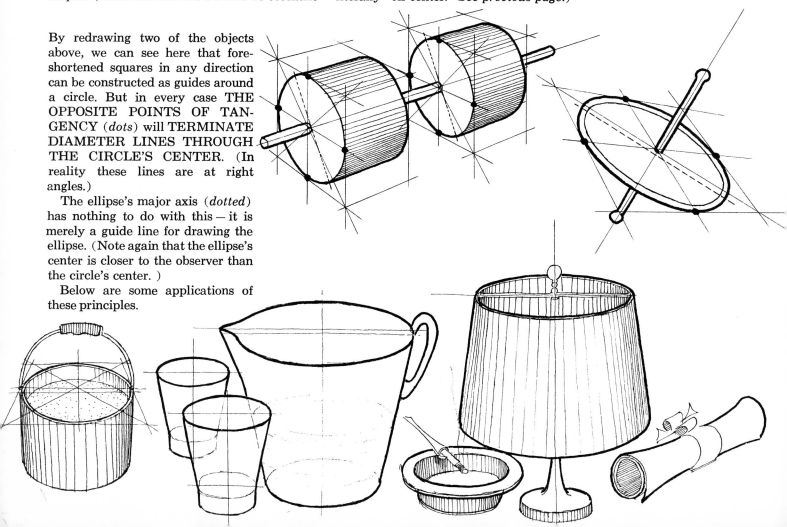

Drawing cones is similar to drawing cylinders. The center line of a cone is also an extension of the related ellipse's minor axis . . . it lies at right angles to the ellipse's major axis . . . and it connects to the ellipse not at the ellipse's center point, but behind it. Study these various principles in the drawings above.

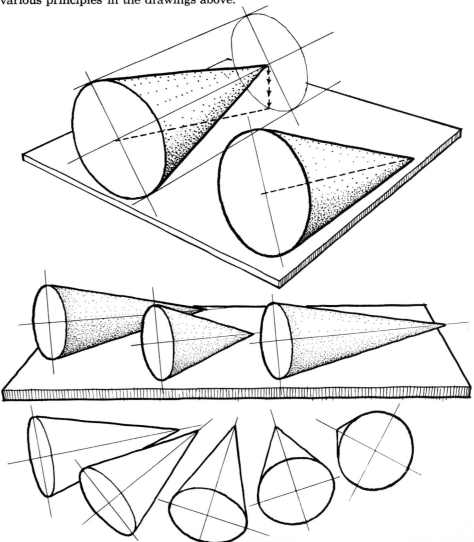

The cone within the cylinder (*right*) naturally has its center line parallel to the table top. Therefore the cone's apex is in the air. To draw the cone resting on the table its apex must drop (*arrows*) so that its center line falls approximately to the dotted line.

The cone at far right is drawn with this dropped center line. (This motion slightly foreshortens the length and makes the ellipse "rounder.")

THEREFORE, CONES LYING ON THEIR SIDES HAVE CENTER LINES INCLINED TO THE PLANES ON WHICH THEY REST.

The similarity of the ellipses at right indicates that these cones are similarly oriented but of different lengths.

While here the varying ellipses and foreshortened lengths suggest that the cones are pointed in various directions and are approximately similar. (Note that the sides of the cone always connect to the ellipse tangentially.)

Circles, ellipses, cones, cylinders and spheres applied to a "Space Age" drawing.

Chapter 14: SHADE AND SHADOW

First, let's clarify our terms: SHADE exists when a surface is turned away from the light source. SHADOW exists when a surface is facing the light source but is prevented from receiving light by some intervening object.

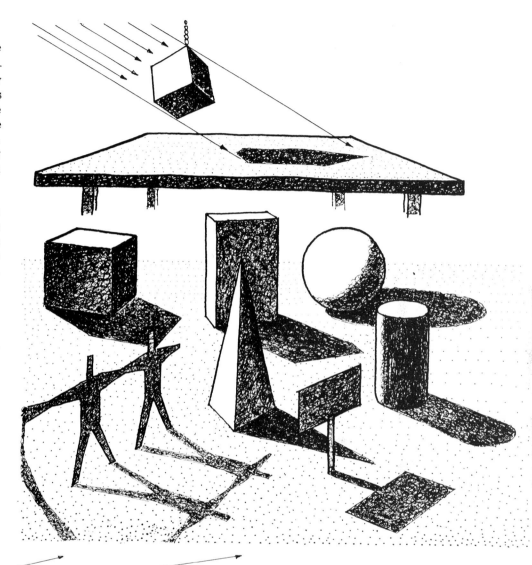

For example: This suspended cube has several surfaces in light and several in shade (those turned away from the light). The table top is turned toward the light and would be entirely "in light," except for the shadow "cast" on it by the cube above. We might say that the intervening object's shaded surface has "cast" a shadow on the lighted surface.

The SHADE LINE is that line which separates those portions of an object that are "in shade" from those that are "in light." In other words, it is the boundary line between shade and light. This shade line is important because it essentially casts, shapes, and determines the shadow. (*Right.*)

Note that the shadow line of a flat, two-dimensional object is its continuous edge line. (One side of the object is in light, the other in shade.)

Shade and shadow naturally exist only when there is light. Light generally is of two types, depending on its source. One type produces a pattern of parallel light rays, the other a radial pattern.

EARTH

The sun, of course, radiates light in all directions, but the rays reaching the earth, being 93 million miles from their source, are essentially a small handful of single rays virtually parallel to one another. Therefore, when drawing with sunlight the rays of light should be considered parallel.

The other type of light originates from a local point source such as a bulb or candle. Here, the closeness of the light source means that objects are receiving light rays that radiate outward from a single point. Therefore, when drawing with local point sources the rays of light should be radial.

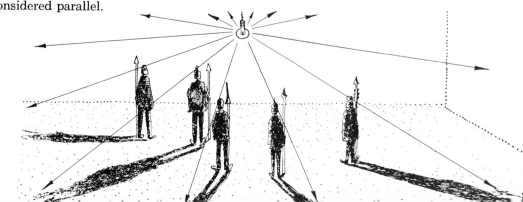

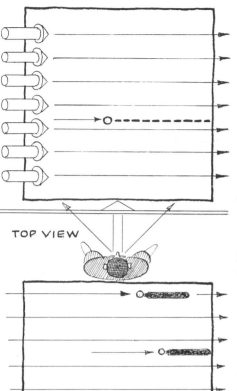

TOP VIEW

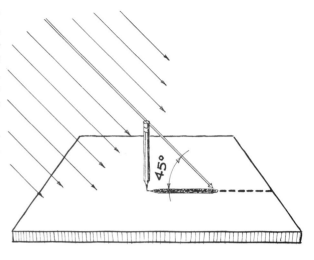

The top view at left shows observer looking at a table which has a pencil (*small circle*) stuck into it. The parallel light rays arriving from the left are parallel to the observer's face and to the picture plane. Therefore, the pencil's shadow must lie along the light ray shown dotted.

The shadow's length depends on the angle of the light ray, but this can only be seen in perspective (*right*). All angles are possible. Here, we use 45 degrees, which makes the shadow's length equal to the pencil's length. The light ray from eraser to dotted line locates the eraser shadow and hence fixes the length of the pencil's entire shadow.

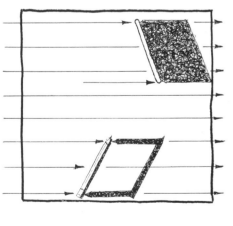

Similar pencils will cast similar shadows. The shadows at left are all parallel to one another and to the picture plane. Therefore in perspective they remain parallel. Note individual light rays "casting" eraser shadows on table.

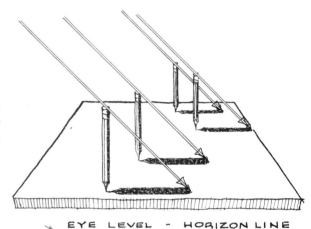

EYE LEVEL - HORIZON LINE

Here, the two pencils at lower left are "bridged" by a third pencil which casts a new shadow line connecting the eraser shadows of the first two. This new shadow must be parallel to its shade line (bridging pencil), therefore, in perspective, both shade line and shadow use the same vanishing point. The other pencils in this drawing are "filled in" to form an opaque, two-dimensional plane. Its shadow is outlined exactly as before, so in both cases the outline pencils are the shade lines which determine the shadow's shape.

Now let's build two cubes using the existing two planes as sides. This creates new shade points at 1 and 2 which cast shadow points 1^s and 2^s. These points help locate the shadow lines (*shown dotted in top view*) of the new top and vertical shade lines. Note the two vertical shade lines of the above drawing that have ceased to be shade lines here, since they are no longer boundaries between light and shade.

EYE LEVEL - HORIZON LINE

TOP VIEWS

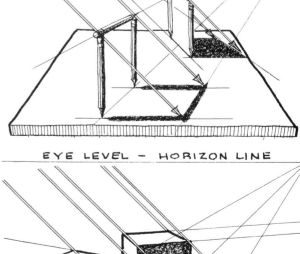

Therefore, the principles developed on the previous page will be evident. Note: *Arrowed lines* are light rays used to locate important shadow points. *Dotted lines* are temporary guide lines required to locate shadows.

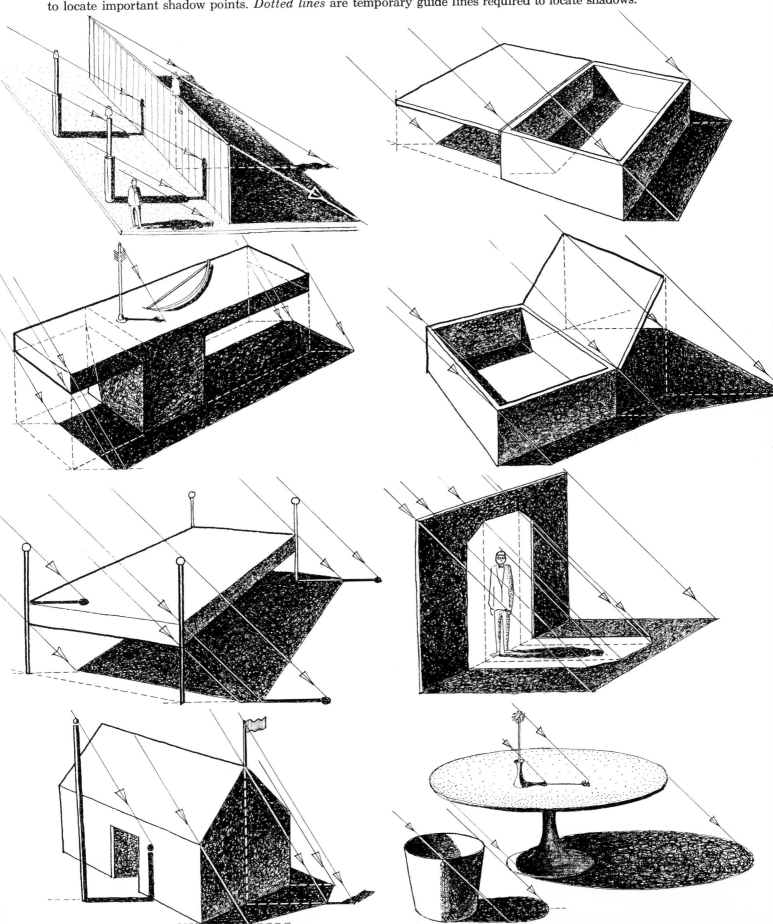

LIGHT RAYS' VAN. POINT

1. When the rays are not parallel to observer's face (and picture plane) then they must appear to converge. This means more complex drawing but it does enable us to represent shadows the way we usually see them in sunlight.

In the top view below, light rays arrive at the angle shown by arrows. Therefore the pencil's shadows must lie along the dotted lines. As before, equal pencils cast equal and parallel shadows. In this case, though, the shadows are oblique to picture plane, so in perspective (*right*) they converge to a point on the horizon line.

2. How do we draw the light rays that determine the shadow lengths? Previously, when the rays were parallel to the picture plane, we simply drew them parallel to one another. But now, being oblique, they must converge.

Their vanishing point, furthermore, must lie on the same vertical vanishing line as the shadows' vanishing point. Why? Because both the rays and the shadows lie on parallel planes (*see top view. For a review of vertical vanishing lines, see pages 77-80*).

Once this point is fixed, light rays passing through the erasers locate the correct shadow lengths.

SHADOWS' VAN. POINT

LIGHT RAYS' VAN. POINT

3. Now bridge a pencil across the eraser ends of the two lower left pencils below. Its shadow on the table will naturally connect the shadows of the eraser ends. Since the upright pencils cast shadows of equal length this new shadow must be parallel to the bridging pencil (shade line).

The other two pencils are "filled in" to create an opaque, two-dimensional plane. Again the new top shade line casts a parallel shadow line on the table top.

Though difficult to visualize, this vanishing point is actually the SUN many millions of miles away radiating a handful of parallel (converging because of perspective) light rays.

4. In perspective, these two new sets of parallel horizontal lines will each converge to a vanishing point. Note, though, that these new vanishing points are not essential to the drawing, since all key shadow points can be determined by the same light rays and shadow lines as above. (The new vanishing points can help, however, to verify the results.)

SHADOWS' VAN. POINT

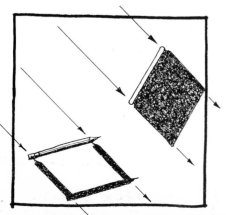

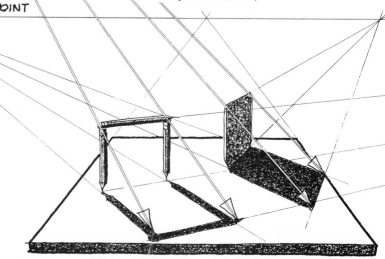

5. Now let's again build two cubes using the existing planes as one side of each. This creates two new shade points 1 and 2 which cast shadow points 1^s and 2^s.

The two new top shade lines again cast shadows parallel to themselves, thus forming two new sets of parallel, horizontal lines, each of which converges to its own vanishing point on the horizon.

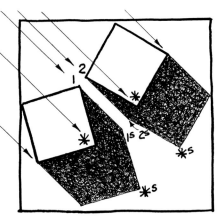

7. In all examples so far the sun has been in front of the observer, and therefore the vanishing point of the parallel light rays has been in fact the sun itself.

What vanishing point is used for the rays when the sun is behind the observer (*top view below*)? The theory is exactly the same. In perspective (*right*) the inclined parallel rays converge to a point, and, as before, this point is located on the vertical vanishing line that passes through the vanishing point of the pencils' shadows (since rays and shadows lie on parallel planes).

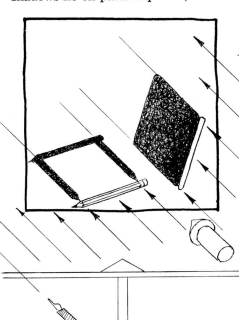

6. Notice that each cube has a total of only two vertical shade lines. The other verticals that had been shade lines in previous steps are now "buried" in shade, *i.e.*, are no longer boundary lines between light and shade; and therefore do not cast shadows. Only their shade points (*) remain to cast shadow points ($*^s$).

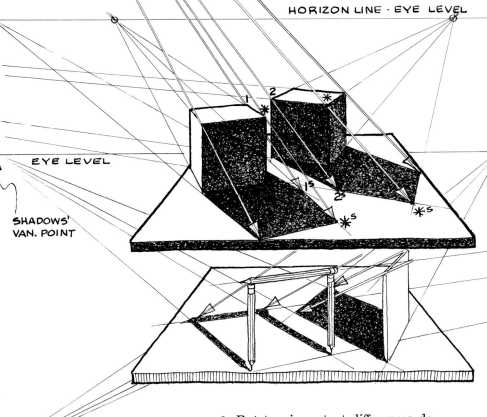

HORIZON LINE · EYE LEVEL

EYE LEVEL

SHADOWS' VAN. POINT

LIGHT RAYS' VAN. POINT

8. But two important differences do exist: 1.) This vanishing point is not the sun itself but simply a vanishing point for a set of inclined parallel lines. 2.) It is *always* below the horizon line. (If above, it would mean the sun is in front of and visible to the observer.)

The side views below, picturing the observer pointing to vanishing points, should explain why this is so.

EYE LEVEL

SUN FROM BEHIND

SUN FROM IN FRONT

The Following Application Sketches All Have Shadows Cast By Parallel Light Rays (Sunlight) Oblique To The Observer's Face (And To Picture Plane)

Therefore, the principles developed on the previous two pages will be evident. Note that when the vanishing point for light rays is close to the horizon the sun is low in the sky and the shadows are long. As the vanishing point increases in distance from the horizon — *either above or below* — the sun rises higher and the shadows become shorter.

Note: *Arrowed* lines are light rays used to locate important shadow points. *Double-arrowed lines* are shadow directions of uprights on ground plane. *Dotted lines* are temporary guide lines required to locate shadows.

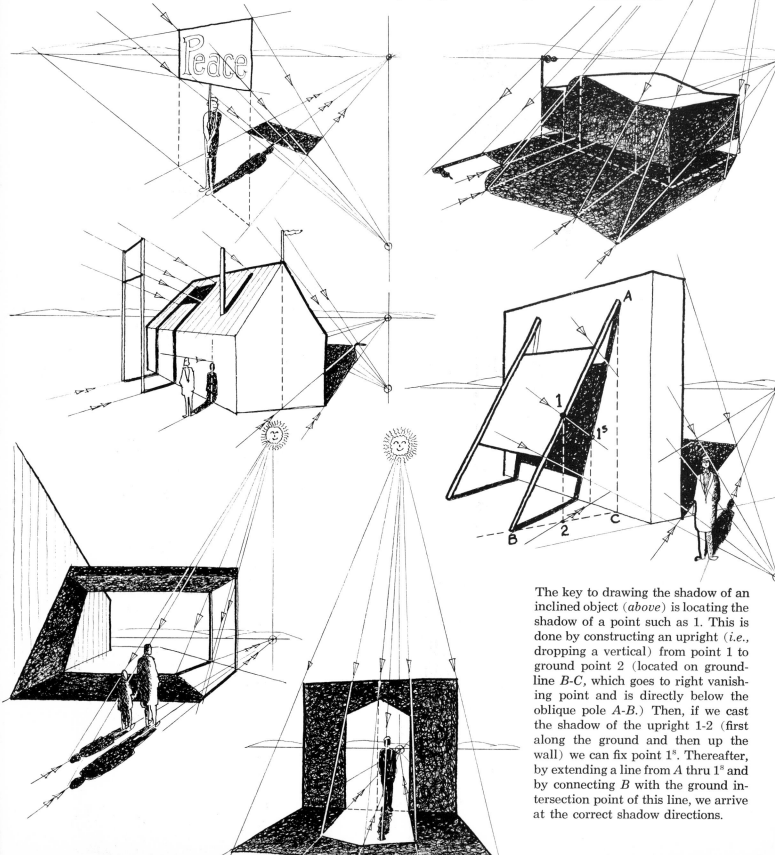

The key to drawing the shadow of an inclined object (*above*) is locating the shadow of a point such as 1. This is done by constructing an upright (*i.e.,* dropping a vertical) from point 1 to ground point 2 (located on ground-line *B-C,* which goes to right vanishing point and is directly below the oblique pole *A-B.*) Then, if we cast the shadow of the upright 1-2 (first along the ground and then up the wall) we can fix point 1^s. Thereafter, by extending a line from *A* thru 1^s and by connecting *B* with the ground intersection point of this line, we arrive at the correct shadow directions.

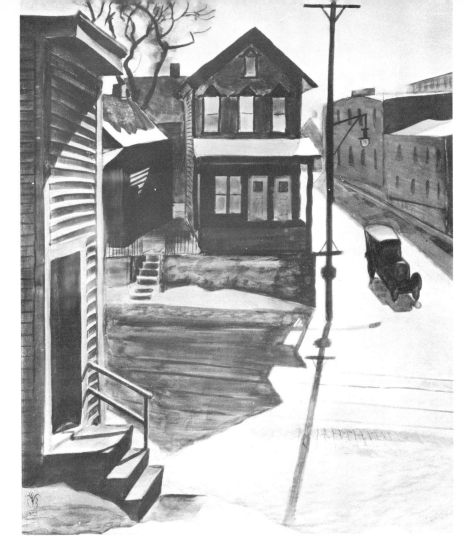

Two unique examples of shade and shadow resulting from sunlight.

Ice Glare, by Charles Burchfield. Collection of Whitney Museum of American Art, New York

Under the Swings, by Robert Vickrey. Collection of Dr. and Mrs. John M. Shuey, Detroit. Courtesy of Midtown Galleries, New York

A light bulb hangs above a table at the point shown in top view. The diverging light rays must cast shadows along the dotted lines. In perspective, these same shadow lines are found by drawing the same diverging lines from the same table point (*asterisk*) through the same pencil points. These lines, naturally, are not light rays, for the actual source of light is somewhere above the table. To determine the exact lengths of the shadows along them, actual rays are drawn (from the light source) through erasers.

RULE: A local point source radiates diverging light rays which locate exact shadow points. *But the shadow direction of upright lines on a plane is determined by lines diverging from the point on the plane that is directly below the light source.*

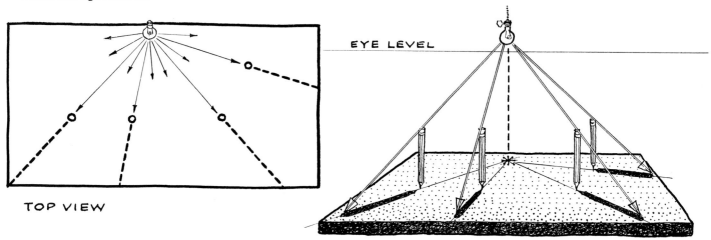

Placing a "bridging" pencil over the lower left pencils and "filling in" the other two to create an opaque plane (*below*) results in two new top shade lines. These lines cast shadows parallel to themselves. The parallel set at lower left, being parallel to picture plane, remain parallel in perspective. The parallel set at right converge to the horizon. RULE: As in the case of parallel rays (sunlight) a straight line casting a shadow on a parallel surface casts a shadow parallel to itself.

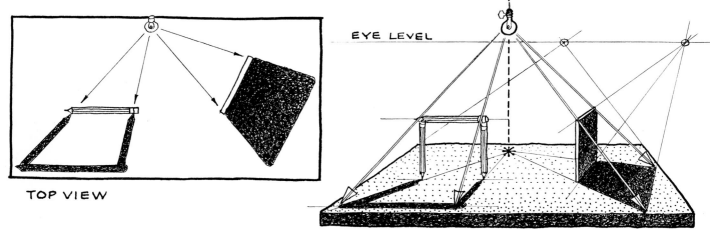

Now let us again build two cubes using the existing planes as one side of each (*below*). This creates three new shade points (1,2,3) which cast shadows points 1^s, 2^s, 3^s. The three new top shade lines again cast shadows parallel to themselves. Therefore, in perspective, these shadows will converge to the vanishing points of their shade lines. (Note how the location of the light creates three top shade lines on one cube but only two on the other.)

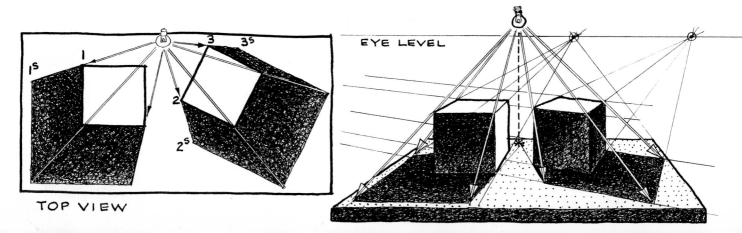

Therefore, the principles developed on the previous page will be evident.

Note: *Single-arrowed lines* are diverging light rays used to locate shadows.

Dotted lines are guidelines which "project" the light source onto the various surfaces (walls, floor, table top, etc.). They originate from the light source and are drawn perpendicular to the surfaces. (The projected light sources are marked by asterisks.)

Double-arrowed lines (originating from the asterisks) are the guidelines that determine the *directions* of shadows cast by shade lines perpendicular to a given surface.

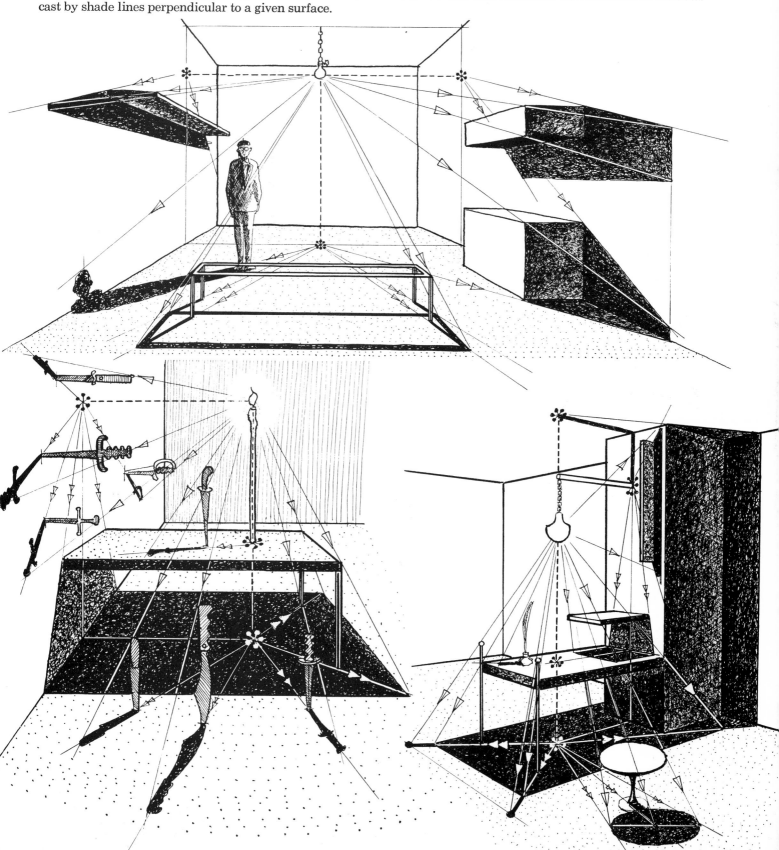

18th-century drawing, artist unknown. Courtesy of the Cooper Union Museum